IMAGES
of America

NORTH BRUNSWICK

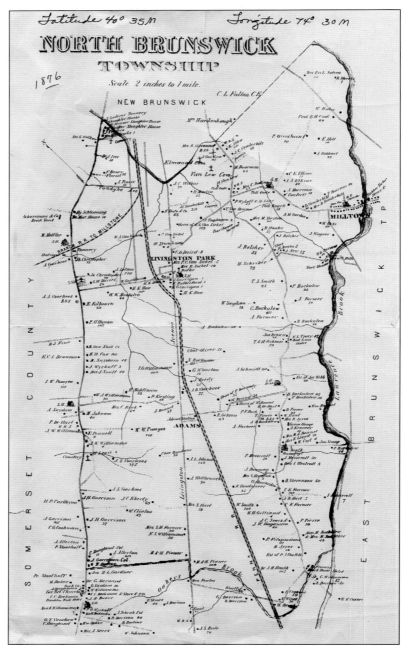

NORTH BRUNSWICK TOWNSHIP. A map from 1876 shows homesteads within the township. (Courtesy of the North Brunswick Historical Society.)

ON THE COVER: MEMBERS OF NORTH BRUNSWICK VOLUNTEER FIRE COMPANY NO. 2. Fire Company No. 2 was organized in 1926. Shown here in 1955 are, from left to right, George Salzmann, Dyke Pearce, Al Rupreck, Marshall Pierce, Steve Skaritka, and Ross Reed. (Courtesy of Fire Company No. 2.)

IMAGES
of America

NORTH BRUNSWICK

North Brunswick
Historical Committee

ARCADIA
PUBLISHING

Published by Arcadia Publishing
Charleston, South Carolina

Printed in the United States of America

Library of Congress Control Number: 2010924842

For all general information, please contact Arcadia Publishing:
Telephone 843-853-2070
Fax 843-853-0044
E-mail sales@arcadiapublishing.com
For customer service and orders:
Toll-Free 1-888-313-2665

Visit us on the Internet at www.arcadiapublishing.com

CONTENTS

ACKNOWLEDGMENTS

The committee would like to give special thanks to the individuals and organizations who helped in the development of this book.

The late Mary Pinkham provided her invaluable and vast collection of North Brunswick memorabilia and photographs. This book would never have come to be if not for Mary's longtime commitment to North Brunswick and preserving its history.

Ruth P. Mihalenko is the author of *North Brunswick: a Township History*, sponsored by the 1976 Bicentennial Committee. Ruth's research and dedication to the committee in 1976 proved very useful in the creation of this book.

Thanks also go to the North Brunswick Public Library, for their assistance; the Canastra family, for contributing their extensive collection of photographs and knowledge of the community as it relates to public safety; the North Brunswick Police Department, Fire Companies 1, 2, and 3, and the First Aid and Rescue Squad, for lending us their photographs and offering their time, support, and assistance; Michael Hritz, for his assistance; Lloyd Staats, for his information regarding the North Brunswick Airport; the New Brunswick Public Library and the New Brunswick Historical Society, for their assistance with the history of Elmwood Cemetery; Ceil Leedom and the South Brunswick Library, for their assistance; Robin Rowand, for photographing Elmwood Cemetery; Cyndi Baumgarten, for lending her collection of Adams School PTA's minute books; Kathleen Kish Moon, for providing her class pictures; and Erin Rocha, our editor from Arcadia Publishing, for all of her patience and guidance throughout this process.

Images used in this book, unless otherwise noted, are from the collection of the North Brunswick Historical Society.

—The North Brunswick Historical Committee:

Janice Larkin	Nansi Krauss
Cheryl McBride	Stanley Levy
Francis "Mac" Womack, mayor	Bob Nutter
Cathy Nicola, councilwoman	Sharon Nutter
Connie Adamo	Vito Puleio
Giovanna Branciforte	George Saloom
Bob Frisch	Richard Selover
Greg Kikelhan	Mark Zielinski

INTRODUCTION

In the early 1600s, North Brunswick's only occupants were members of the Lenni Lenape tribe who lived and hunted along much of the Atlantic coastline. Things have certainly changed since then.

Earliest records of the town note the Black Horse Tavern, which was built in 1670 and served as a stagecoach stop and the Lion Tavern. Both were on Georges Road, which was named after England's King George.

Although there had been scattered population in the area for several years, the first permanent settlement came in 1761. People arriving in New Amsterdam on their way to establish homesteads and build new lives were lured south by stories of fertile lands. Settlers purchased their land from the Native Americans and proceeded to build homes and plant crops. Despite hardships, the pioneers stayed on and this section of New Jersey became a flourishing agricultural community as well as one of the most populated rural areas in the New World.

By 1750, a gristmill had been put into operation on Farrington Lake near the spot where the present dam is located. It was later joined by a snuff factory and a tannery. From 1775 through 1900, the area remained almost entirely agricultural. Nonetheless as population increased, so did auxiliary development, and by 1784 the area boasted 19 merchant shops, eight taverns, three gristmills, one sawmill, one fulling mill, three tanyards, and one brewery.

North Brunswick was one of the first townships to be organized after the formation of Middlesex County by the General Assembly of East Jersey in 1682. At that time it included a total of 23,000 acres of land. Over the years, it was divided, with approximately 15,000 acres having been separated from it in 1860 for what were to become East Brunswick and New Brunswick. In 1903, the Borough of Milltown broke away. It has proudly been known as North Brunswick since its first incorporation date of February 28, 1779. However due to previous minutes that were lost, the township had a second incorporation recorded on February 21, 1798.

During the American Revolution, North Brunswick's central location placed it along main transportation routes, and it saw both Washington's troops and the British march along what is now Route 27 (also known as Lincoln Highway) on their way to and from critical engagements in New York, Trenton, Princeton, and beyond.

The early schoolhouses were built by subscription, and the teachers paid by those who were able to do so. The first reference in township records for the provision of education of those who were unable to pay was made in 1827, when it was ordered that $500 be raised for the education of the poor children of the township. The first school committee was elected two years later, in 1829, and the first school budget was set at $250. A free school system was adopted in 1851. There were two schools in the township at that time, one being the Red Lion and the other Oak Hill.

The Georges Road Baptist Church, erected in 1847, was the first religious structure in the area and is still standing and serving the community. The building is known for its distinctive steeple as well as for its charm and beauty.

North Brunswick is a large township, encompassing approximately 12 square miles situated in central Middlesex County. The current population is approximately 39,800. Located in one of the most populous regions of the United States, snuggled between New York City and Philadelphia and located at the halfway point between Boston and Washington, D.C., North Brunswick retains a small-town heart. Carrying on the traditions of community and neighborliness passed down from its earliest settlers to the newest residents, North Brunswick stands out as a community of caring people and volunteers. All of the township's fire, first aid, and rescue services are volunteer driven, and people come together year after year to ensure its youth sports programs, food bank, and other community service organizations remain people-based and compassionate.

This book is dedicated to the wonderful North Brunswick residents of generations past and present, whose fortitude, foresight, compassion, and volunteer involvement have truly made North Brunswick a wonderful place to live.

One

THE EARLY DAYS

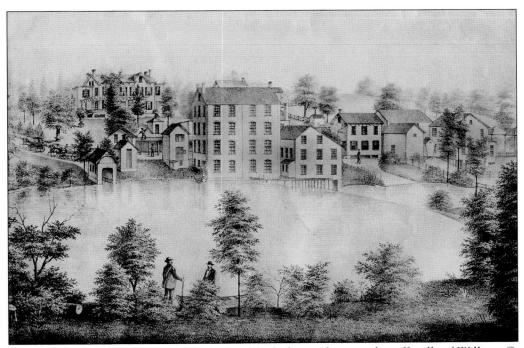

SNUFF MILL. Portrayed here in 1860 is Brookford, the residence and snuff mills of William G. Parsons. The greatest impact on growth within North Brunswick was made by the mills. As early as 1750, waterpower from the Lawrence Brook was harnessed to provide energy to operate the mills along its banks. A snuff mill was built about three-quarters of a mile from the border of Milltown at a point called Brookford.

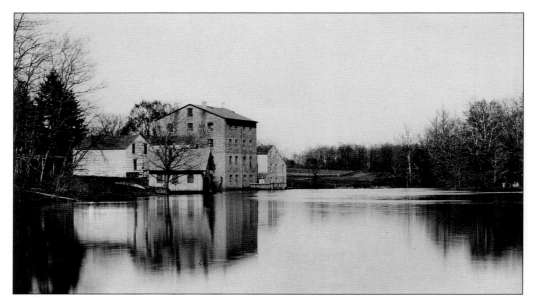

THE PARSONS BROOKFORD SNUFF MILL. In the 1800s, the mill was taken over by Jacob Bergen, and the area became known as Bergen's Mills. Ownership of the various mills changed frequently, and in 1856 the one pictured here was sold to William Parsons, under whose direction the name was changed to Parsons Brookford Snuff Mill. This picture was taken around 1870. (Courtesy of the New Brunswick Public Library.)

THE RESIDENCE OF JAMES M. PARSONS. This is the home of James M. Parsons, son of William G. Parsons. It was located near the snuff mill along the Lawrence Brook. The name Parsons continues to live on in North Brunswick with the Parsons Elementary School, which was named in honor of the family. This picture was taken about 1870. (Courtesy of the New Brunswick Public Library.)

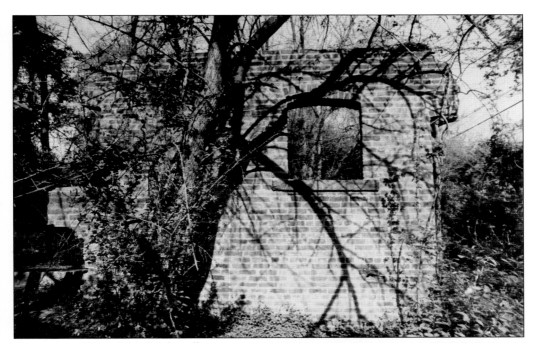

CRUMBLING WALL. This brick wall is all that remains of the original Parsons Brookford Snuff Mill. The wall is located in the woods on the banks of the Lawrence Brook, which was engineered to become Farrington Lake, one of the current water supplies for the City of New Brunswick.

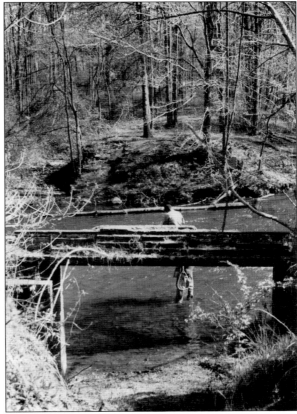

OLD RAILROAD TRACKS. Local sportsmen now enjoy a favorite springtime activity of freshwater fishing in the shadow of a rotting wooden trestle that formerly carried electric trolleys of the Brunswick Traction Company across Farrington Lake around the beginning of the 20th century. (Courtesy of the North Brunswick Department of Parks, Recreation and Community Service.)

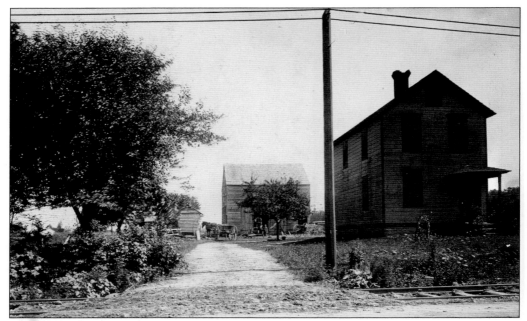

BODINE HOUSE. Berdine's Corner was farmland in the 19th and first half of the 20th centuries. In 1896, the Bodine house was located on Milltown Road across from the future Brunswick Shopping Center. Trolley tracks ran in front of the house. Electric cars of the Brunswick Traction Company were put into service between New Brunswick and Milltown in 1895. The automobile forced the trolley out of business by 1930, and in 1937 the tracks were removed.

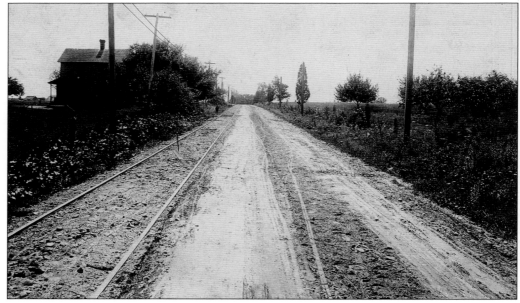

MILLTOWN ROAD. Modern travelers in North Brunswick may not recognize this dirt lane, but this is what Milltown Road looked like around 1895. The apple orchard on the right, noted for its abundant wildlife, is now the site of the Brunswick Shopping Center, and the trolley tracks at left were part of the line running through the township into Milltown.

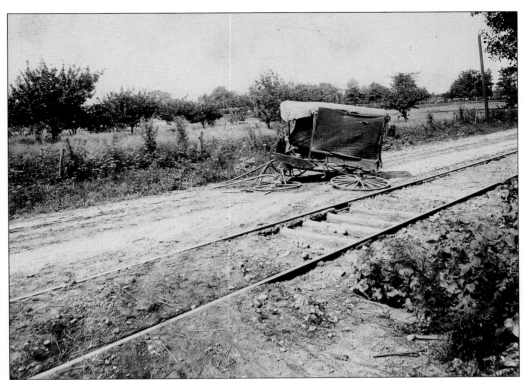

STILLMAN WAGON HIT BY TROLLEY CAR. Samuel Moyes Stillman, age 70, and his horse were killed after his wagon was hit by a trolley car as he was coming out of the Bodine House driveway on Milltown Road in 1896 not long after the tracks were installed. The orchard seen behind the wreck of the wagon is now the site of the Brunswick Shopping Center.

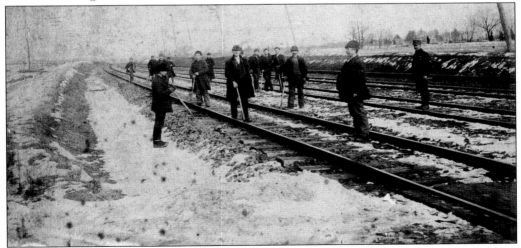

WORKING ON THE RAILROAD. Pictured in this photograph around 1900 are the original Adams Station railroad tracks that were located on Adams Lane near the current Route 1 intersection. The railroad connected the town to both New York and Philadelphia. The township's only station was a minor one located in the Adams section of town, and use of this as a passenger station was discontinued in the mid-1950s.

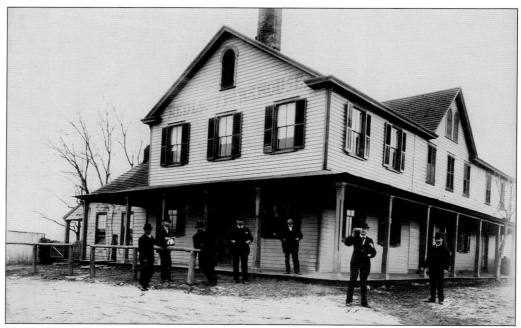

THE RED LION TAVERN. North Brunswick was the home of several taverns although no remnants of them remain today. These establishments served as social and political centers for public meetings as well as a place for stage riders to spend the night. The Red Lion Tavern was founded before 1800 and was located on a bend of the original Georges Road. This picture was taken around 1890. (Courtesy of South Brunswick Public Library.)

HOW FAMILY HOUSE. This house was built in 1840 by Rev. Samuel Blanchard How (1790–1868), the minister of the First Reformed Dutch Protestant Church in New Brunswick from 1832 to 1861. In 1857, How published his infamous work *Slave Holding Not Sinful*, in which he gave biblical justification for slavery. Located on the street that would be named for the family, the house was demolished in 1987.

THE OLD FORGE. The Old Forge was the name given to the Halase house located in the southern part of town along Route 27. The barn that was located behind this farmhouse has been preserved and moved to the East Jersey Olde Town, located in Johnson Park in Piscataway.

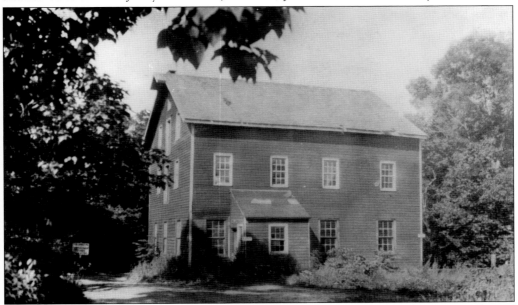

DAVIDSON'S MILL. The earliest industries in North Brunswick were snuff mills, gristmills, and sawmills. Beginning in the mid-1700s, D. Davidson ran a gristmill on a large parcel of land that was on the border of North and South Brunswick. A gristmill is a place where farmers brought their wheat to be ground into flour. The building, shown here in 1930, is no longer standing, but the land is now part of Davidson Mill Pond Park in nearby South Brunswick.

The Township Committee would respectfully recommend that the
following sums be appropriated for the ensuing year:

APPROPRIATIONS RECOMMENDED FOR 1912.

Roads ... $800.00
Poor .. 600.00
Incidentals ... 850.00
Board of Health.. 100.00

W. H. VINCENT,
A. YORSTON,
F. G. HART,
Township Committee.

Attest—
LOUIS E. PHILLIPS,
Township Clerk.

District Clerk's Financial Report to the Township Committee

*Report of the District Clerk of School District of North Brunswick
Township, County of Middlesex, for the School
Year Ending June 30, 1911.*

FINANCIAL REPORT.

RECEIPTS

STATE AND COUNTY FUNDS.

Balance in hands hands of custodian, July 1st, 1910
From $200,000 state school fund appropriation.... $51.05
From state appropriation....................... 17.65
From state school tax.......................... 1,470.97
From reserve fund.............................. 114.22
From railroad tax.............................. 426.67

Total $2,080.56

DISTRICT TAXES.

Balance in hands of custodian, July 1st, 1910, from
current expenses............................... $932.74
From current expenses.......................... 1,000.00
From building and enlarging school houses........ 500.00

Total $2,432.74

Grand total $4,513.30

6

)istrict Clerk of School District of North Brunswick
ship, County of Middlesex, for the School
Year Ending June 30, 1911.

FINANCIAL REPORT.

EXPENDITURES

STATE AND COUNTY FUNDS.

salaries.........................$1,804.90	
∙r, for retirement fund...........	32.60
...	113.91
∙n of pupils to schools in other	
...	129.15
...............................∙...............	$2,080.56

DISTRICT TAXES.

∙ges...........................	$80.00
apparatus and supplies...........	92.35
∙n of pupils to schools in other	
...	142.66
∙pils in other districts............	669.00
∙pection........................	39.50
repairing and refurnishing school	
...	754.54
∙l expenses......................	166.95
∙ls of custodian, June 30th, 1911,	
∙expenses.......................	487.74
...............................∙..............	$2,432.74
...	$4,513.30

FINANCIAL STATEMENT OF THE NORTH BRUNSWICK SCHOOL DISTRICT. The school finance report was combined with the township financial statement in 1911. As reported by collector and treasurer John A. Bodine, other expenditures for the town included under the poor fund account were "reimbursement to S. M. Press for boarding tramps" and "coal for Mary Cornell." Under the road account were "cash paid to Joseph Phillips, Bert Pardun, and James Buckelew for road work" and "cash paid to S. M. Press for extra road work including storing a road scraper." Other accounts included the board of health, incidentals, and the sheep fund. Also included in this booklet were seven pages of names of residents delinquent with their taxes.

7

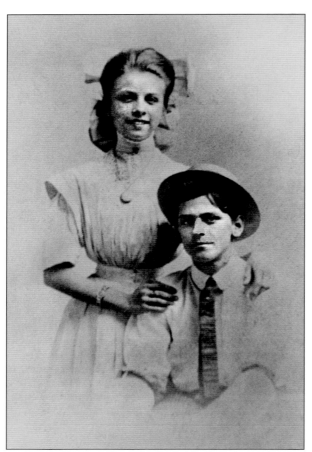

BERDINE'S CORNER RESIDENTS. Here is the engagement portrait, taken in 1916, of Frederick Ryan Willar (1890–1977) and Sylvia Stevens Dunn (1893–1963). Sylvia, born and raised in New Brunswick, met Fred, born in Canada, in the New Brunswick Woolworth's store where she worked. They built their home on Elmwood Place in 1927 in Berdine's Corner, raised their daughter Sylvia Jeanne there, and are buried together in Elmwood Cemetery. (Courtesy of John McBride.)

NEW JERSEY DRIVER'S LICENSE FROM 1927. Frederick Willar's New Jersey driver's license from 1927 listed the section of town that he lived in, Berdine's Corner, rather than listing North Brunswick. Driver's licenses were good for one year, and the fee was only $3. (Courtesy of Jeff and Cheryl McBride.)

Auto Driver's License

This License Expires
December 31, 1927.

No. 352466.

Issued to.................... FREDERICK R. WILLAR

Street Address........... ELMWOOD PL.

City or Town.............. BERDINES COR.

DESCRIPTION OF LICENSEE

Age.......36.....Weight......150.....Color......W...... Color Hair.....BLK....

Sex......M......Color Eyes......BR......Height....5–9.....Fee $3.00

Signature of Licensee......*Fredrick R Willar*

This certificate must be carried by the Licensee when operating a motor vehicle.

WILLAR–FREDERICK R. A 15-7-1-26-M2500

A TROLLEY TRIP. Sylvia Stevens Dunn, age 10, poses in front of the Trenton and New Brunswick trolley car. This photograph was taken in 1903. (Courtesy of Jeff and Cheryl McBride.)

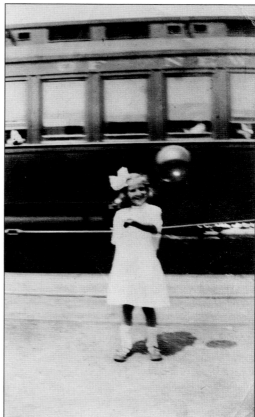

PORTRAIT OF A LITTLE GIRL. This is a formal birthday portrait taken of Sylvia Stevens Dunn at age 10 at a local photography studio in New Brunswick. This photograph was taken in 1903. (Courtesy of Jeff and Cheryl McBride.)

THREE GENERATIONS OF A NORTH BRUNSWICK FAMILY. Starting with Mary C. Van Deursen, photographed here in 1890, the Van Deursens lived in the Berdine's Corner section of town. Mary was the wife of Ross D. Van Deursen and the mother of Eleanor Van Deursen. As seen throughout this book, Van Deursen is a prominent name in North Brunswick.

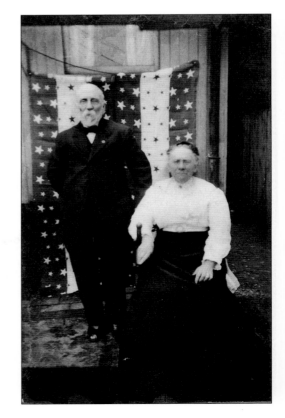

JUSTICE VAN DEURSEN. Ross Van Deursen was the justice of the peace and constable from 1885 through 1900. He is pictured here with his wife, Mary C. Van Deursen.

FORMAL BIRTHDAY PORTRAIT. This portrait of Eleanor Van Deursen was taken at Holler's Art Gallery at 379–381 George Street in New Brunswick to commemorate her fifth birthday in 1893.

ENGAGEMENT PORTRAIT. Taken at a photography studio on Albany Street in New Brunswick, this is a portrait of Eleanor Van Deursen. Eleanor was a charter member of the Livingston Avenue Baptist Church, worked for Johnson & Johnson, and was married to Elmer C. Hardy. Eleanor died on December 14, 1971, at age 83 and was buried in the Van Liew Cemetery in North Brunswick.

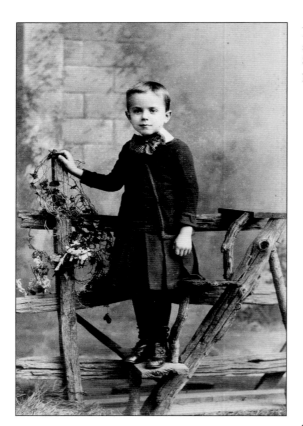

PORTRAIT OF A LITTLE BOY. Elmer Hardy, age three, is shown in a portrait by the Scott Studios of New Brunswick. This photograph was taken around 1870.

LITTLE BOY GROWS UP. Elmer Hardy began working for Johnson & Johnson in 1888 and continued there until 1912. Hardy returned to Johnson & Johnson in 1916 and remained there until 1935, at which point he retired. Elmer married Eleanor Van Deursen, and they lived in the Berdine's Corner section of North Brunswick. Elmer died in 1954.

LITTLE BO PEEP. Mildred Hardy, seen here in a portrait from 1928, was the daughter of Elmer C. and Eleanor Hardy. Elmer and Eleanor raised their family on Linwood Place.

EARLY FARMHOUSE. Pictured here is the farmhouse of the Otkin family that is located on the southbound side of Route 130. After a long legal battle with a developer, this 105-acre parcel of land was developed by the township into the North Brunswick Community Park.

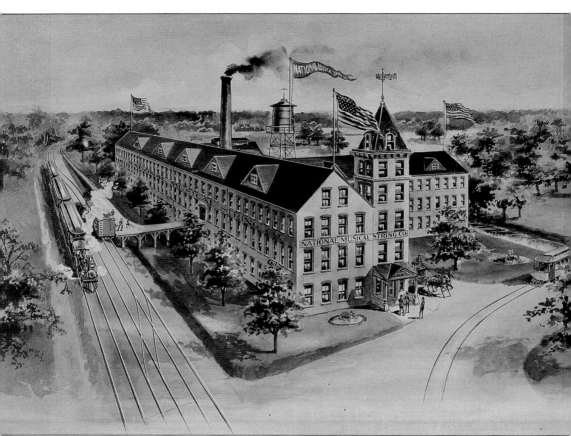

NATIONAL MUSICAL STRING COMPANY. The National Musical String Company was incorporated in 1897, formed by the merger of the Standard Musical String Company, Rice Musical String Company of New York, and a craftsman, George Emerson. Seeking a nice, clean, brick building on a site where female help would be available, the company had contacted a real estate broker in New Brunswick. The firm bought the foundation and brickwork, worth $2,000, at a sheriff's sale for $700. By 1898, the company had erected a building and opened with 120 employees and an annual payroll of $40,000. Strings for guitars, banjos, violins, and mandolins were manufactured here along with guitar picks and harmonicas. It was, for a while, the sole manufacturer of harmonicas in the United States. Located on Georges Road, adjacent to the former Raritan River Rail Road Line, this building was listed on the National Register of Historic Places in 1982.

Two

SCHOOL DAYS

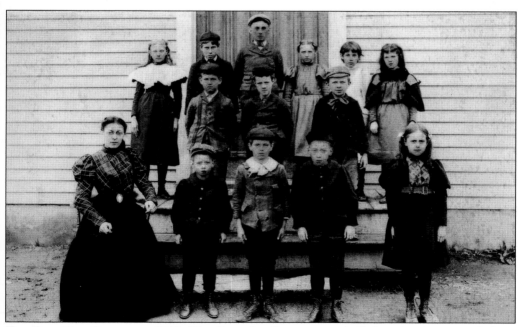

THE OAK HILL SCHOOL C. 1861. The first schoolhouses were built by subscription, and those families who could afford it paid the teachers. The first records of education being provided for the poor appear in 1827, when it was ordered that $500 be raised for that purpose. In 1829, the first school committee was elected with members including Staats Van Deursen, Lewis Hardenbergh, Peter Dayton, James Gable, and Isaac Brower.

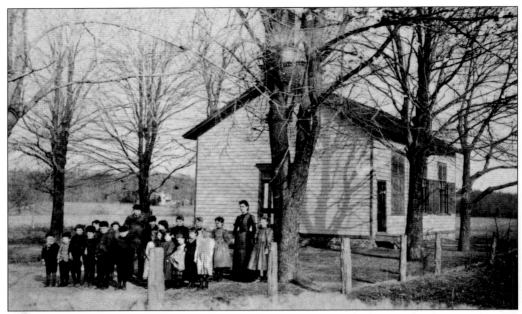

OAK HILL SCHOOL. North Brunswick's oldest known school, which is no longer in existence, was the Oak Hill School established around 1840. This school was located on Route 1 North near the Milltown border. The earliest print record in 1861 notes that George B. Wright was the teacher. Wright later became the Reverend Wright and was known to be one of the most renowned Methodist ministers in the state.

THE RED LION SCHOOL. The Red Lion two-room schoolhouse educated the children in the Maple Meade section of town. The school that was on Old Georges Road burned down in the mid-1920s, and a larger building was constructed across the road in 1926. The newer structure now houses the board of education offices and is no longer used as a school.

EDUCATING FOR THE FUTURE. This picture from 1920 depicts the boys-only mechanical drawing class at the Maple Meade School. In preparation for their future careers, most boys wore jackets, shirts, and ties to class every day.

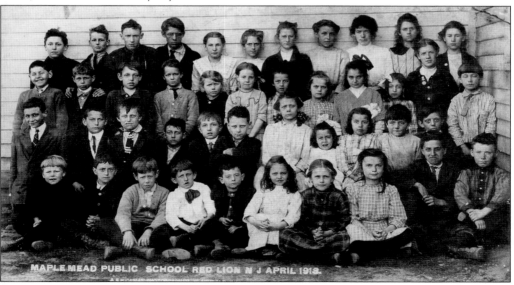

MAPLE MEAD PUBLIC SCHOOL RED LION N J APRIL 1913.

THE MAPLE MEAD(E) SCHOOL. The Maple Meade School was originally named the Red Lion School, but to avoid confusion with the tavern, the name was changed to the Maple Mead(e) School. This picture taken in April 1913 shows Jesse Applegate (fourth row, second from right), who later became the principal of the school. The spelling of Maple Mead(e) has not been consistent through time and has varied between Maplemead and Maple Meade.

27

Primary Department.

FIRST YEAR.
Reading.—Chart, Primer, first half of First Reader.
Spelling.— Chart and Reader.
Language.—Talking Exercises, Reproduction.
Arithmetic.—One to ten, signs. Roman numerals.
Geography.—Talking Exercises, Description of locality, rain, snow, sun, moon, stars.

SECOND YEAR.
Reading.—First Reader completed.
Spelling.— Words selected from Chart and Reader.
Language.—Printed work, Capitals, Abbreviations.
Arithmetic.— One to twenty. Notation. Numerals.
Geography.— Talking Exercises. Cardinal points. Use of maps.

THIRD YEAR.
Reading.—Vowels and consonants. Second Reader. Supplementary Reading.
Spelling.— Words selected from Reader. Accent.
Language.—Reproduction Stories. Pronouns. Script.
Arithmetic.—One to one hundred. Tables developed. Notation. Measures.
Geography.— School district, County and State.

FOURTH YEAR.
Reading.— Third Reader, Supplementary Reading.
Spelling.—Words selected from Reader and Primary Speller. Syllabication. Use of Dictionary.
Language.—Letter writing. Story telling.
Arithmetic.—Addition, Subtraction, Multiplication and Division. Weights and Measures. Cancellation and Factoring.
Geography.— Home Geography, Primary Geography introduced. N. J. Capitals U. S.
Writing.—Vertical writing. Book I. and II.

State of Ne~

Department of Pub

Middlesex County--Pupil Certific

This is to certify that _Eleanor Van Deursen_, course of study prescribed for the _Grammar_ depar School District of _North Brunswick_ and has, record as a student, fully established _her_ right to receive to the higher years of school work.

In witness whereof, we have set our hands

_____ Sup. Principal.

_____ Principal.

Emma A. Williamson Teacher.

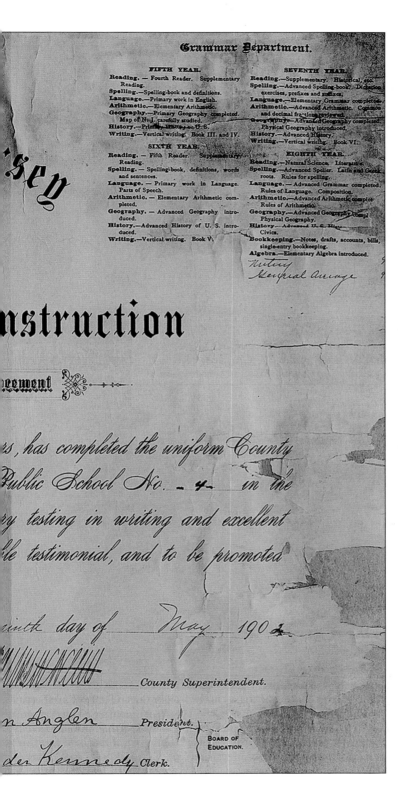

CERTIFICATE OF ADVANCEMENT, 1902. Eleanor Van Deursen, at age 13, completed the uniform county course of study prescribed for the grammar department at the Livingston Park School in May 1902. This certificate indicates that she graduated from Livingston Park School and was now able to attend high school. Since North Brunswick did not have the facilities to educate its students past the eighth grade, they had to attend high school in New Brunswick or in parochial schools. Education in the late 1800s and early 1900s was very basic, with students studying reading, writing, arithmetic, geography, and history.

THE COMPLETE MONTHLY REPORT CARD.

School No. _3_ Primary Dep't, _____

3 Place _Maplemead_

Year Grade. Division

Record of _Agnes Pulda_ for the school year

ending _June 1920_

Alice D. Hilcox Teacher

Transfer Certificate.

_____ aged _____ years has been a pupil in this school, is in

good standing and is entitled to admission to the _____ year grade.

_____ Principal.

Monthly Report Card. Agnes Pulda and her family lived on a farm on Old Georges Road, which is still in existence. Agnes attended Maple Meade School during the 1919–1920 school year. Her teacher was Alice D. Hileax. Agnes was rarely absent, was never late, and her deportment was fair to good. She did well in reading and spelling, and although her writing skills improved over the course of the year, she never attained a grade better than fair. The column for the drawing class is not filled in because only boys were allowed to take the course.

N. B. 10—Perfect. 9—Excellent. 8—Good. 7—Fair. 6—Poor. 5—Very Poor.

	Sessions Absent	Times Late	Deport- ment	Reading	Spelling	Writing	Drawing	Arithmetic	Language Lessons	Geography	Signature of Parent or Guardian.
Sept.	0	0	8	8	9			8	7		*Louis Pulda*
Oct.	0	0	7	9	9	5		8	7		*Louis Pulda*
Nov.	2	0	8	9	9	5		9	8		*Louis Pulda*
Dec.	2	0	8	9	9	5		9	10		*Louis Pulda*
Jan	0	0	7	9	9	6		10	8	8	*Louis Pulda*
Feb.	2	0	Mid Ex	90				93			*Louis Pulda*
March	0	0	7	9	10	7		9	8		*Louis Pulda*
April	0	0	8	9	10	7		10	9		*Louis Pulda*
May	0	0	8	9	10	7		9	9		
June	Final	Ex.		90				78			
Average			76	90	93	60		88	83		*promoted.*

Copyright 1894 by Daniel Slote & Co., Publishers, New York.

PARSONS SCHOOL FUND-RAISERS. During the 1920s, Parsons School was built on Mill Lane, which was later renamed Hermann Road in honor of mayor Fred Hermann. In 1967, a new Parsons School was built on Hollywood Street, next to Babbage Park. At this same time, the original Parsons School was remodeled and converted into the town's municipal building. The name Parsons pays tribute to William Parsons and his snuff mill, which had a profound affect on early township industry and growth. The Parsons Parent-Teacher Association started a traditional minstrel and dance fund-raiser in 1932.

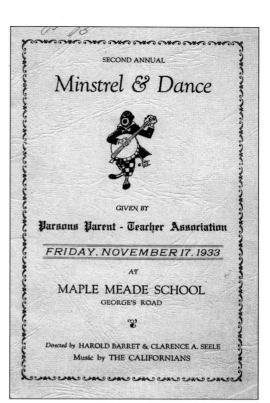

SECOND ANNUAL

Minstrel & Dance

GIVEN BY

Parsons Parent - Teacher Association

FRIDAY. NOVEMBER 17. 1933

AT

MAPLE MEADE SCHOOL
GEORGE'S ROAD

Directed by HAROLD BARRET & CLARENCE A. SEELE
Music by THE CALIFORNIANS

Compliments of
NEW BRUNSWICK SHOE HOSPITAL
Guaranteed Work at a Fair Price
You will wear out your shoes hunting for a better place to repair them
318½ GEORGE ST. NEW BRUNSWICK N. J.

J. S. IVINS' SON INC.
Broad and Mount Vernon Streets
PHILADELPHIA, PA.

PROGRAM—Continued

11. You Oughta Hear Olaf LaffEdward Bochert
12. Irish Mother ..Jack White
13. Hawian SpecialtyDe Palo Brothers
14. River, Stay 'way From My DoorBarrett and Company
15. She Lives Next Door To A Firehouse................Henry Hefner
16. Dance Speciality, Little Hunk of Love....Anna Ochs and Frank De Troy
17. Closing Numbers — { Good Night Sweetheart } —Entire Chorus
 { Roll On, Mississippi, Roll On }

Compliments of
H. W. BROWN
TIRES — TUBES
89 French Street

Compliments of
BERNARD THOMAS

ADMISSION TICKET

NEW JERSEY STATE POLICE - KEYSTONE AUTOMOBILE CLUB SAFETY PATROL OUTING.

Athletics vs. Cleveland
TUESDAY, May 4, 1948.
Shibe Park, Philadelphia.

USE SOMERSET STREET PASS GATE ENTRANCE
1:30 P. M.
COURTESY OF THE PHILADELPHIA ATHLETICS

SCHOOL TRIP TO PHILADELPHIA. On Tuesday May 4, 1948, the eighth-grade school safety patrols from Maple Meade, Livingston Park, and Parsons School were treated to an outing to celebrate their year of service to their schools. Patrol members went to a baseball game at Shibe Park in Philadelphia to see the Athletics play Cleveland. The New Jersey State Police and the Keystone Automobile Club sponsored this adventure.

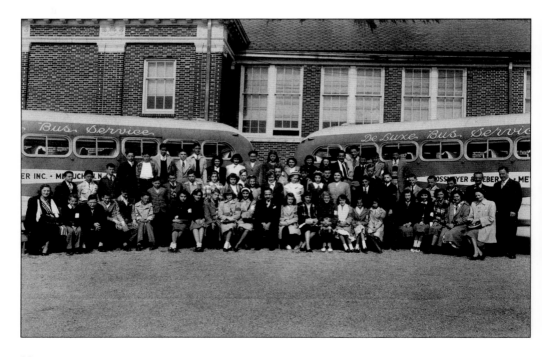

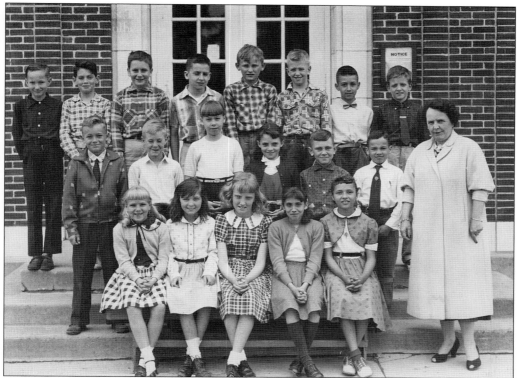

FOURTH GRADE AT MAPLE MEADE SCHOOL. Teacher Mrs. Thomas's class sits for their formal portrait on the steps of the Maple Meade School. The photograph includes, from left to right, (first row) Linda Van Deursen, Patty Cralew, Geraldine Ogla, Monique Reed, and unidentified; (second row) unidentified, Ken Hulick, Gayle Urban, Arlene Gillhuly, Andy Kankula, and Andy Lopez; (third row) unidentified, George Roberts, two unidentified, Steve Broro, two unidentified, and Antone Lemmle.

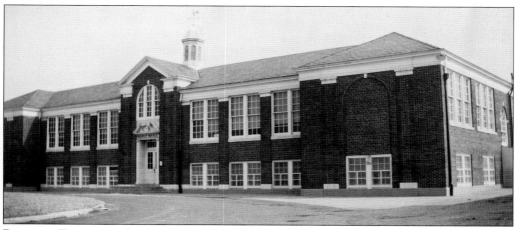

BOARD OF EDUCATION OFFICES. After a long history of being one of the original schools, the new Maple Meade School was converted into board of education offices in 1973 and is no longer used to house or educate students. There is no longer a school called Maple Meade. The building is located on Old Georges Road right off Route 130, next to the Pulda Farm.

ADAMS SCHOOL
PARENT-TEACHERS ASSOCIATION
NORTH BRUNSWICK TOWNSHIP
1960 - 1961

THEME

PARENTS AND TEACHERS

PARTNERS IN EDUCATION

THE ADAMS ELEMENTARY SCHOOL. The Adams Elementary School was a two-room schoolhouse located on Route 1 South opposite Cordelia Street. It was established in the early 1900s, abandoned for some time, and was pressed into use again between 1951 and 1961 because of an influx of population. Grace Macaro was the principal and teacher during these later years, when two classrooms, one bathroom, and a lunchroom served about 40 children, most of them a combination of brothers, sisters, and cousins. The Adams School was named after a family that had settled early in North Brunswick.

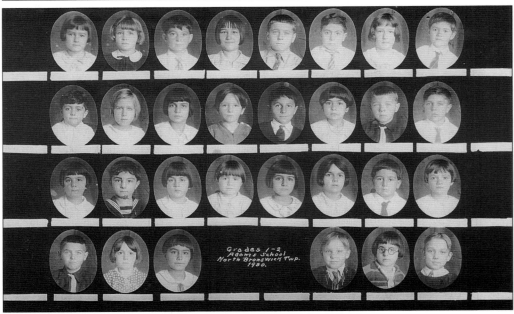

Adams School Reunion
November 3, 2002

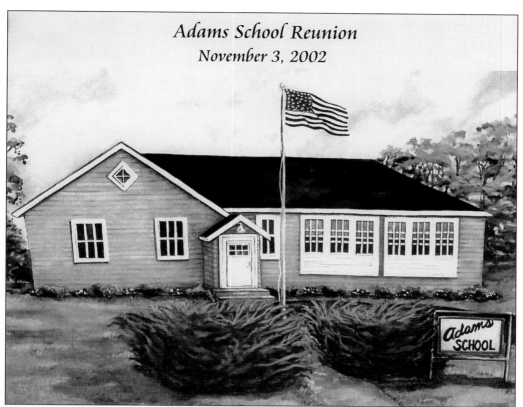

FOND MEMORIES. Interesting notes found in the minutes from 1960s PTA meetings mention that on March 21, 1960, Harold Austin, head of the civil defense organization in North Brunswick, spoke about the importance of being prepared in the event of a nuclear attack. There was a polio clinic held on April 30, 1960, where an inoculation could be received for $1.50. In 1960, Dorothy Kramer presented a program explaining the importance of filmstrips as a supplement in teaching. At a meeting in November 1958, a film, *High Wall*, was shown on how gangs start and why they do. The picture shown above of the Adams School was painted by Allison Ricciardelli. The photograph below is from a reunion on November 3, 2002, and shows alumni reconnecting with old friends. (Courtesy of Cyndi Baumgartner.)

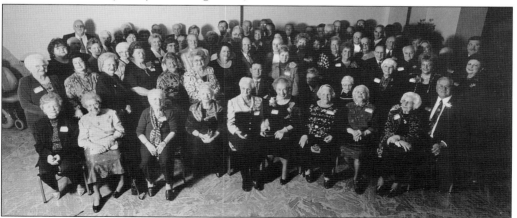

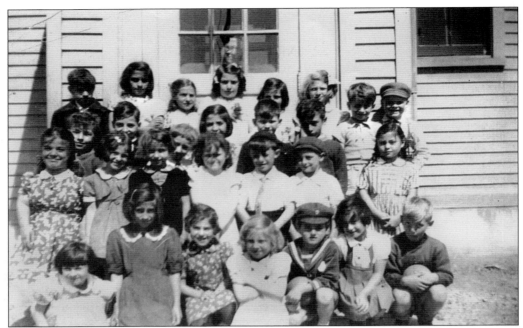

CLASS OF 1939. This photograph captures students of the class of 1939 at the Adams School. The teacher is Mrs. Eaton, who can be seen peeking out of the window. In the third row, the first person from the left is Joseph Sabella. While serving during the Korean War, he was killed in action. Sabella Park on Cozzens Lane was named in his honor.

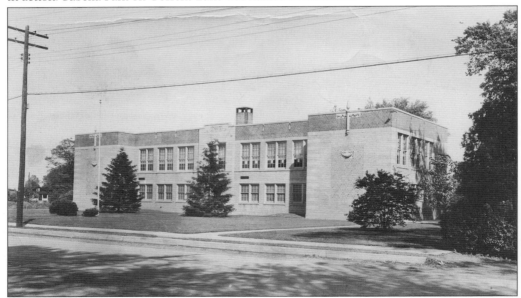

LIVINGSTON PARK SCHOOL. In the late 19th century, a school was needed in the vicinity of Livingston Park because children could not attend elsewhere due to the lack of good roads. Land for this school was donated by George Mettler. The original building had one room with a potbellied stove for heat. That building was destroyed by fire in 1928, and the current structure was completed in 1930.

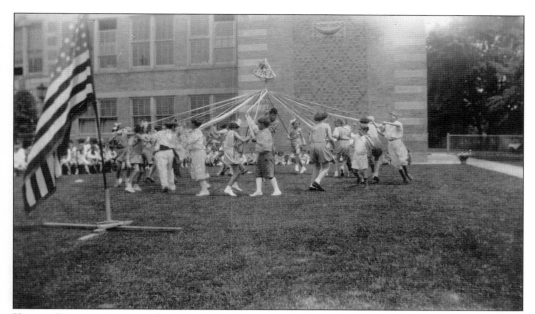

YEARLY RITUAL. An annual celebration of spring took place on the front lawn of Livingston Park Elementary School with a dance around the maypole performed by the students. This tradition was maintained until after the erection of the new brick school building in 1930.

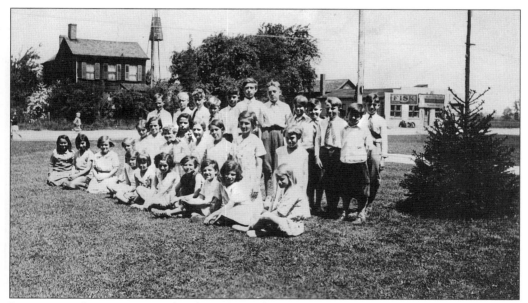

LIVINGSTON AVENUE VIEW. The class of 1935 happily poses for a picture on the front lawn of the Livingston Park Elementary School. The school fronts Livingston Avenue. A house with a wind-powered water pump can be seen in the background.

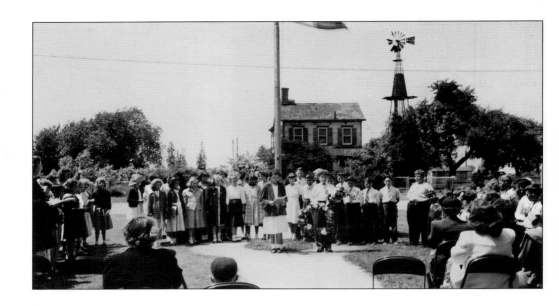

MEMORIAL DAY CEREMONY. In 1948, an assembly in honor of Memorial Day was held at the Livingston Park Elementary School. The meeting adjourned to the school grounds where wreaths were placed near memorial trees for Charles Kern Sr., a Spanish-American War veteran and former employee of the school; Charles Trabayho, a World War II veteran who lost his life in the Pacific; Nancy Previte, a former pupil of the school; and William Myers, a former school employee. A wreath was placed at the base of the flagpole for all those who gave their lives for their country.

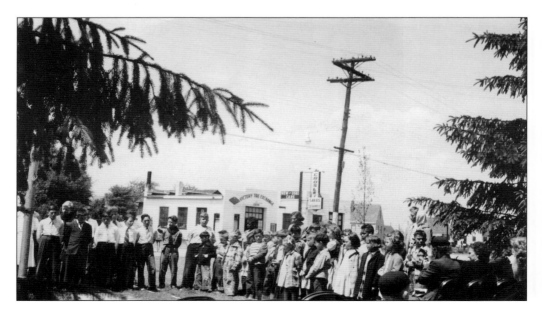

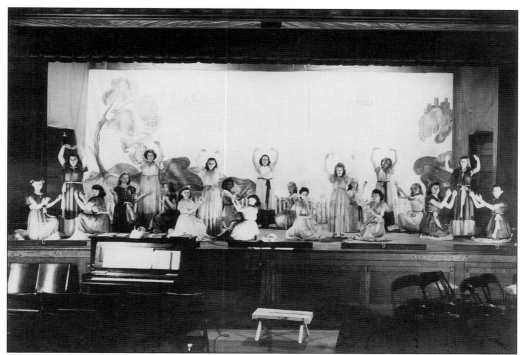

WELCOMING SPRING. Female students in the Livingston Park Elementary School rehearse a dance performance in the auditorium to welcome spring in the 1950s. The program was under the direction of Mary Delaney, school principal, while Marjorie Haggett, supervisor of music, accompanied on the piano.

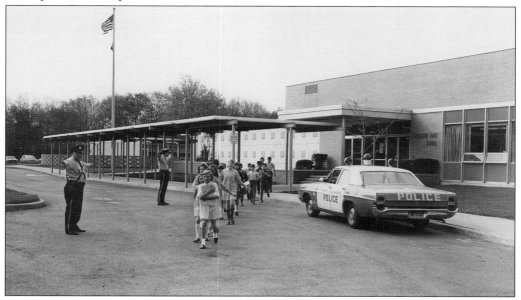

LIVINGSTON PARK EXPANDS. As enrollment went up, the need for more room was obvious. In 1964, an addition was built to accommodate registered students. Shown here in the mid-1960s, the North Brunswick Police Department helps students exit the new school building safely.

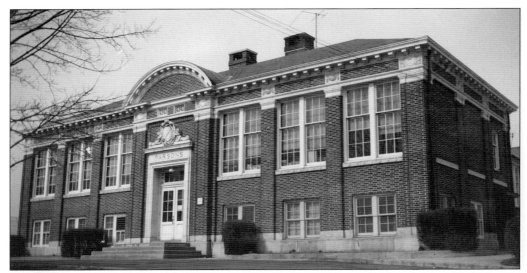

PARSONS ELEMENTARY SCHOOL. The Parsons Elementary School was located at 711 Hermann Road and was the first school in Berdine's Corner since the Oak Hill School was demolished. In 1966, the school became the Municipal Building, the home of the police station and the new public library. Seen here in the 1960s, the building was constructed in the 1920s and torn down in 1993.

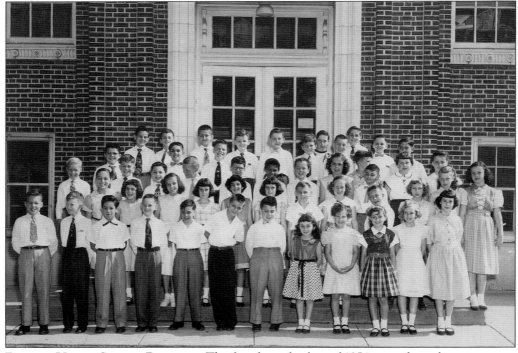

DRESSED UP FOR SCHOOL PORTRAIT. The fourth-grade class of 1954 poses for a class picture on the stairs of the Parsons Elementary School. The little boy pictured in the third row, third from the left is Peter Stemmer, who grew up to be a teacher at Linwood Junior High School in the late 1960s.

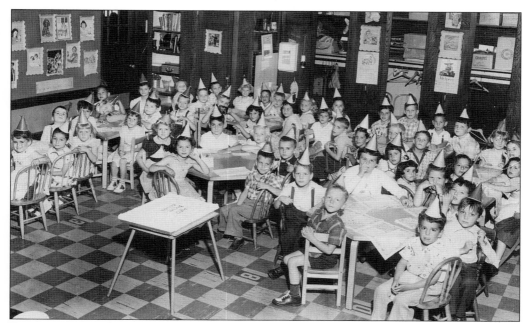

BIRTHDAY HATS. Shown here in June 1955 are Angela Akerley's combined morning and afternoon kindergarten classes at the Parsons Elementary School. Party hats and a big cake help to celebrate for the students who will have summertime birthdays. (Courtesy of Kathleen Kish Moon.)

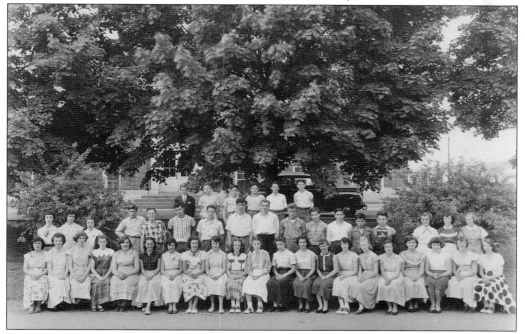

SADDLE SHOES AND BIG SKIRTS. This photograph of upper classmen at the Parsons Elementary School was taken in the late 1940s. Students featured in this image include Janet Judd, Joan Micale, Louis Willis, Jackie St. Pierre, Rose Ann Norcia, Mary Snediker, Irene Szabo, Salvatore Bongiovani, and Patricia Bernath.

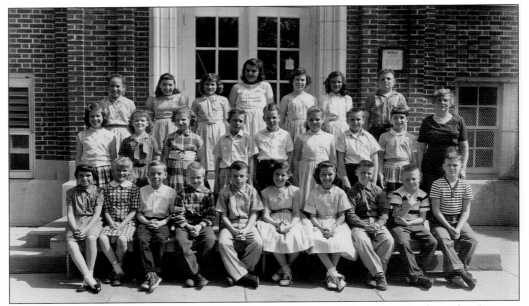

CLASS PICTURE. On this beautiful fall day, Francis E. Conner's fourth-grade class of 1959 poses on the steps of Parsons Elementary School. The students pictured look eager to start another year of learning. (Courtesy of Kathleen Kish Moon.)

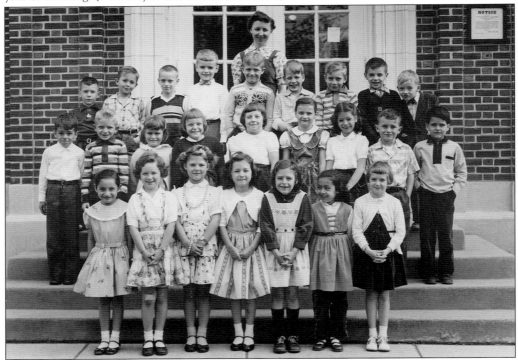

HAPPY FIRST GRADERS. Irene Centers's first graders stand proudly in front of the Parsons Elementary School in 1956. First graders are often so enthusiastic and so happy to start on their school journey. (Courtesy of Kathleen Kish Moon.)

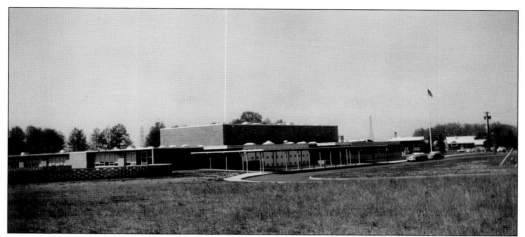

JOHN ADAMS ELEMENTARY SCHOOL. The new John Adams Elementary School was opened on Redmond Street in 1961 near the Route 27 corridor. Due to unanticipated growth in population, an addition was constructed the following year. Interestingly, John Adams was the only "all walking" school in the township in 1976 with most of its students coming from the Brunswick Knolls and Indian Head developments.

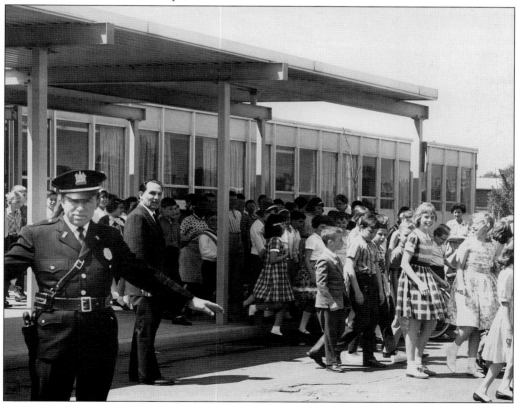

SAFETY FIRST. School is out for the students of John Adams Elementary School as police chief Carmen Canastra is present to make sure the children exit safely during a fire drill in 1965. (Courtesy of the Canastra family.)

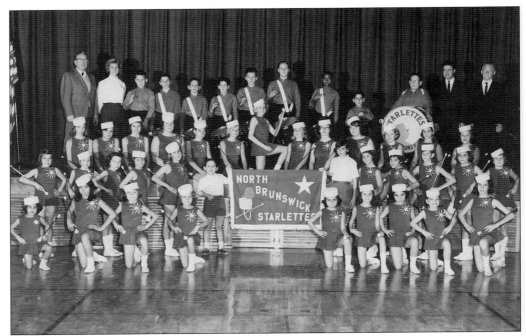

NORTH BRUNSWICK STARLETTES. Shown here in the early 1960s are the North Brunswick Starlettes, a band and baton twirling team. Baton twirling was a popular activity for girls in the 1950s and 1960s. Since sports opportunities were very limited for them at this time, the North Brunswick Starlettes filled the bill by providing an outlet for girls to participate in a physical activity.

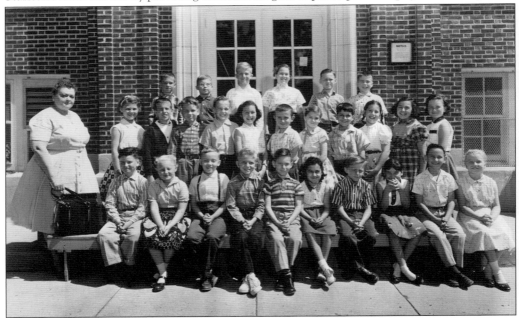

HAPPINESS IS . . . BEING IN THIRD GRADE. Margaret Lambert's third graders smile for the camera in their 1958 class photograph in front of Parsons Elementary School. (Courtesy of Kathleen Kish Moon.)

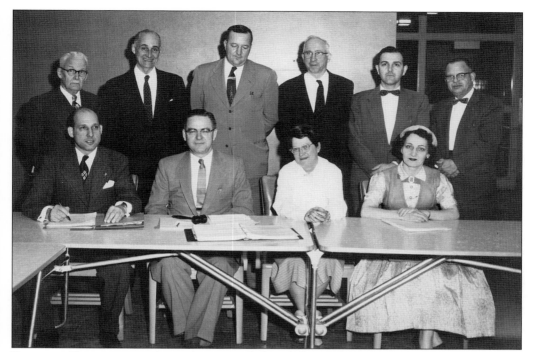

BOARD OF EDUCATION, 1956–1957. Pictured, from left to right, are (first row) Wilton Kimmer, Bernard Ludwig, Marion Ingham, and Joan Bono; (second row) George Davis, Fred Jacobsen, future mayor Ken Rupprecht, John Small, Ted Acchione, and Arthur Judd. The township's newest elementary school, the Arthur M. Judd School, opened in 1967 on Roosevelt Avenue and was named to honor this former superintendant of schools.

MOVING ON UP. Loretta MacDonald's fifth graders pose on the Linwood Junior High School lawn in this 1960 class photograph. At this time, Linwood Junior High School was used to educate fifth- through eighth-grade students. (Courtesy of Kathleen Kish Moon.)

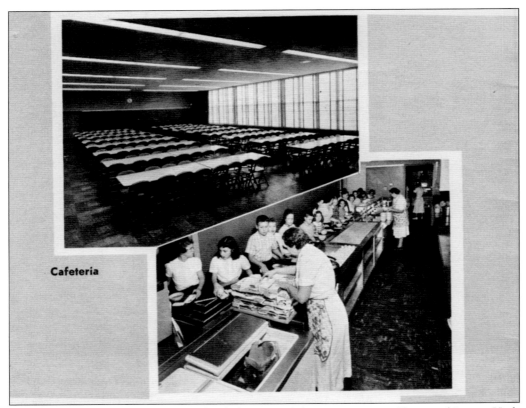

Cafeteria

LINWOOD JUNIOR HIGH SCHOOL. The dedication of the cornerstone of Linwood Junior High School took place on December 1, 1951, with the theme "Universal Education is the Foundation of Democracy." The school has undergone many expansions. Pictured here from 1955 is the expansion dedication program when the second-floor addition was completed. At various times over the years, the school was used to house fifth through ninth grades. In the 1950s, ninth-grade students could follow any one of four curriculum patterns: preparation for college, which included studying Latin; preparation for business, which offered junior business training and typing; general preparation, which included wood shop to boys and home economics to girls; and a general preparation with a shop major.

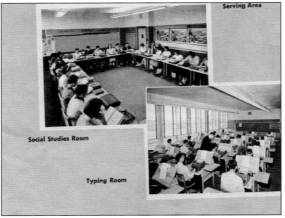

Serving Area

Social Studies Room

Typing Room

Three

PAUSE TO REFLECT

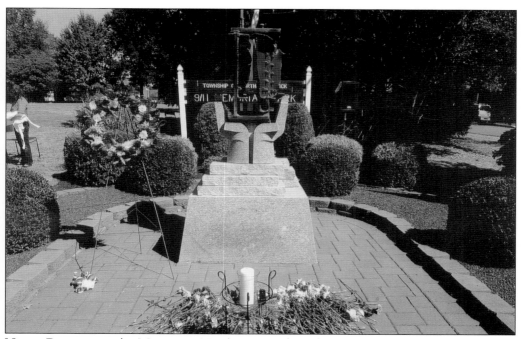

NORTH BRUNSWICK 9/11 MEMORIAL. North Brunswick residents remember neighbors who died in the terrorist attacks of September 11, 2001. The monument, designed by Donato's Monuments in Rahway with the assistance of artist Robert Buczynski, incorporates two pieces of steel recovered from the World Trade Center. Victims of the attacks with personal ties to North Brunswick include Alan J. Lederman, Sheryl Rosner-Rosenbaum, Timothy Stackpole, Glen Davis Kirwin, and James Corrigan.

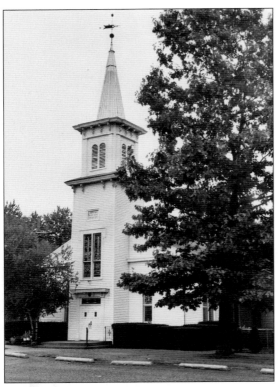

GEORGES ROAD BAPTIST CHURCH. One of the oldest buildings in the township, the Old Georges Road Baptist Church was organized in 1843 and dedicated on March 17, 1847. At the time, 33 members were enrolled, and the following families were represented: Messeroll, De Hart, Provost, Suydam, Buckelew, Creamer, Drake, Thompson, Bound, Sperling, Bennett, and Hendricks. The first pastor was Rev. David Perdun.

OUR LADY OF PEACE ROMAN CATHOLIC CHURCH. The first place of worship for Catholics in North Brunswick was this wooden chapel of Our Lady of Peace Church, erected on Route 130 and Pershing Avenue by volunteer workers in 1946. The chapel was torn down and replaced by a new parish center in 1974. The Reverend Joseph Mizerak was named the first resident pastor.

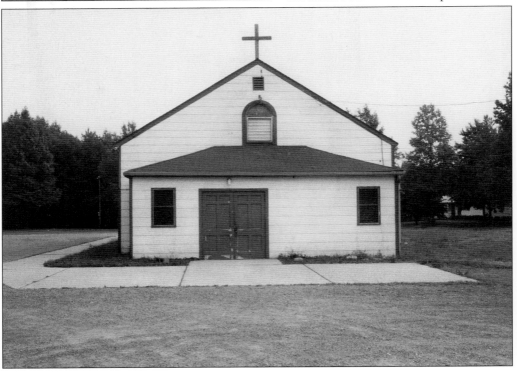

THE NORTH BRUNSWICK COMMUNITY REFORMED CHURCH. The North Brunswick Community Reformed Church got its start in this building, still standing in the Berdine's Corner section of town. It formerly housed the New Brunswick Presbyterian Chapel, and the township group purchased the building, dismantled it, moved it to the township, and rebuilt it in 1921.

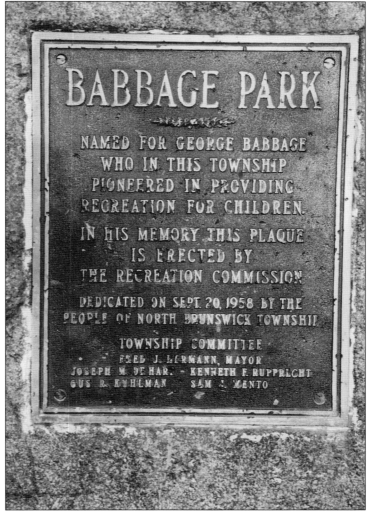

BABBAGE PARK COMMEMORATIVE. Local resident George Babbage was beloved by local children and well known for flooding park areas to create ice skating ponds in the wintertime. Babbage Park was named in his honor and a commemorative stone was placed there in 1958.

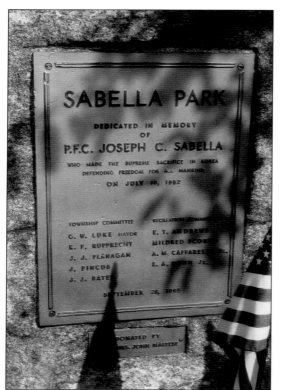

SABELLA PARK TRIBUTE. Joseph C. Sabella was killed in action on Old Baldy Hill in North Korea on July 18, 1952. He served in Company B, 23rd Infantry Regiment, 2nd Infantry Division. Joseph graduated from the Adams School and from New Brunswick High School in 1949. Sabella Park, located on Cozzens Lane, the same section of town in which he lived, is dedicated to his memory.

VETERANS PARK. A veterans memorial was erected on November 11, 1986, and Maple Meade Park was officially renamed Veterans Park. The park is dedicated to the memory of the men who died serving their country and is especially dedicated to George S. Lublinsky, a Maple Meade resident who gave his life in the Korean War while a prisoner of war.

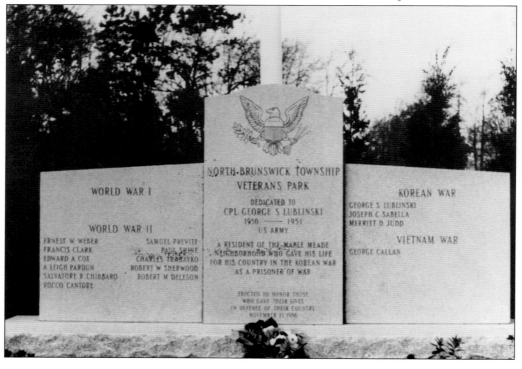

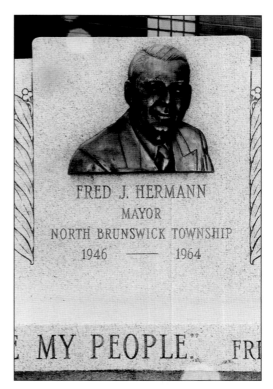

MAYOR FRED J. HERMANN MEMORIAL. Fred J. Hermann, North Brunswick's longest-serving mayor, was actually chairman of the township committee until the title mayor came into use during the early 1960s. Hermann Road, which was formerly Mill Lane, was renamed in his honor. The Hermann monument, dedicated at the same time as the Municipal Building in 1967, was relocated from 711 Hermann Road, across the street to the front of the new Municipal Complex in 1993. The site of the complex is the former site of the Hermann Trucking Company.

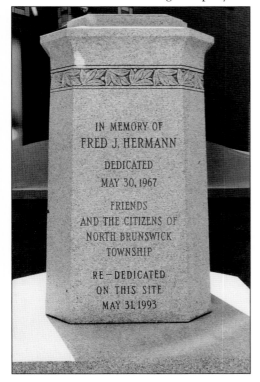

THE NORTH BRUNSWICK PUBLIC LIBRARY. In 1967, the North Brunswick Public Library opened in two classrooms on the second floor of the Parsons School at 711 Hermann Road, which had recently been converted into the Municipal Building. This is the entrance to the building, located above the police station. (Courtesy of Cheryl McBride.)

READY TO CHECK OUT. A new circulation desk finally arrived in 1968. Pictured here are, from left to right, library page Linda Drewiengo, library director Florence Shimko, volunteer Mrs. Busch, and patron Aileene Hansens, wife of Dr. Elton Hansens, the library board of trustees first president. (Courtesy of Cheryl McBride.)

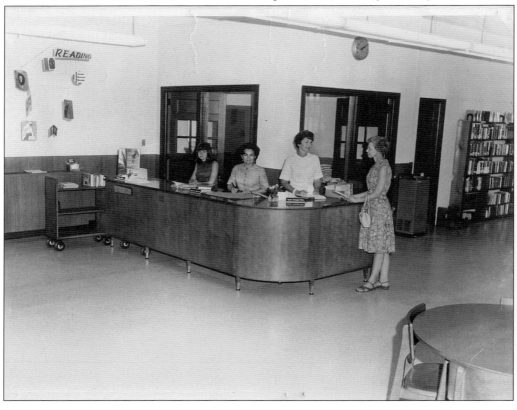

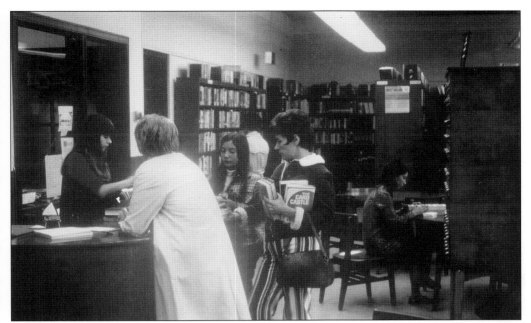

THE LIBRARY OUTGROWS ITS SPACE. By the early 1970s, it was obvious to all that the library had outgrown its two classrooms and was bursting at the seams with books. In the photograph above, books are shelved on top of the stacks and the card catalog is over 6 feet tall. Library assistant Linda Drewiengo helps patrons check out their selections while Cheryl Rebold files catalog cards. The ground-breaking for the present library building at 880 Hermann Road (below) was held in January 1972 with staff members, from left to right, Estelle Glantz, library director Florence Shimko, Linda Drewiengo, Ann Farcas, future library director Cheryl Rebold (McBride), and Sandy Fujiki. (Both, courtesy of Cheryl McBride.)

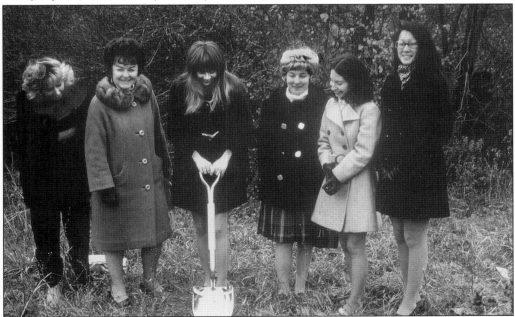

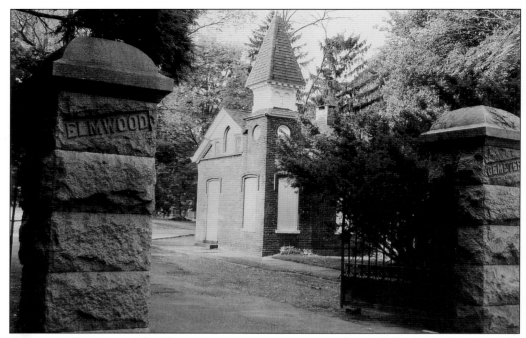

ELMWOOD CEMETERY. The Victorian cemetery movement changed the look of graveyards. Extravagantly landscaped, parklike cemeteries reflecting the Victorian obsession with death were established around major cities. Established in 1868, Elmwood is located on Georges Road. One of its superintendents was Alfred Yorston, a prominent mortician and politician best remembered for moving 520 bodies from the New Brunswick Presbyterian Church's graveyard to Van Liew Cemetery. (Courtesy of Robin Rowand.)

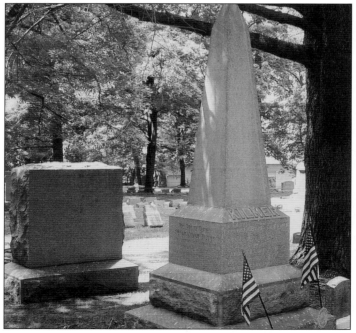

KILMER FAMILY MONUMENT. This centograph honors the memory of Joyce Kilmer, author of the poem "Trees," who was killed in World War I. Memorialized here, Kilmer's body is interred in France. His father, Dr. Frederick Kilmer, helped develop the sterilized bandage for Johnson & Johnson; his mother, Anne Kilburn Kilmer, was an advocate for African Americans and made a bequest to the local hospital that there be no discrimination in helping those who required treatment. (Courtesy of Robin Rowand.)

BOYD FAMILY TOMBSTONE. Hugh Boyd (1845–1923) emigrated from Ireland and became a reporter for the *New Brunswick Times*, eventually buying it in 1880 and renaming it the *Home News*. The daily newspaper exists to this day under the name the *Home News Tribune.* Hugh N. Boyd (1911–1979), his grandson, served in World War II in the Office of Strategic Services (OSS), the precursor to the CIA. (Courtesy of Robin Rowand.)

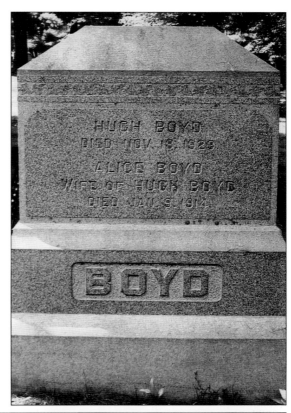

LUDLOW FAMILY MEMORIAL. George Craig Ludlow (1830–1900) was the 28th governor of New Jersey, serving from 1881 to 1884. While he was governor, public libraries were established, child labor laws were passed, and women gained the right to serve on school boards. Ludlow later became a justice of the New Jersey Supreme Court. (Courtesy of Robin Rowand.)

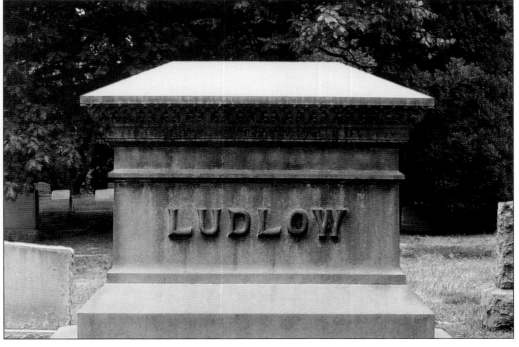

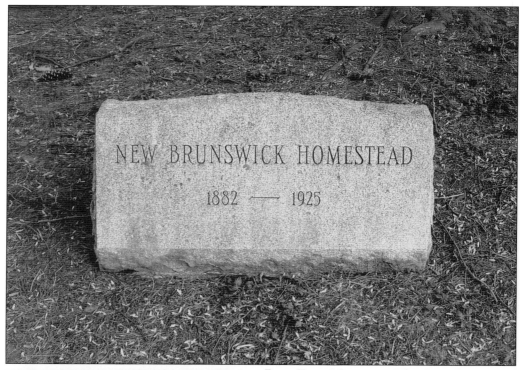

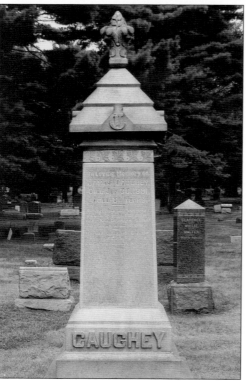

POOR FARM MEMORIAL. The City of New Brunswick along with the Township of North Brunswick maintained a home for indigents on Princeton Road, which is now the intersection of Routes 1 and 130. Although located in North Brunswick, New Brunswick's mayor, John Morrison, was given the opportunity to rename it New Brunswick Homestead when part of North Brunswick was ceded to New Brunswick around 1913. The Poor Farm had its own cemetery, but when the area no longer served as a home for the poor, the bodies were exhumed and buried together. They are memorialized here with a single stone. (Courtesy of Robin Rowand.)

REV. JAMES CAUGHEY GRAVE SITE. Rev. James Caughey was a revivalist Methodist preacher in England before retiring to Highland Park. He had a great influence on the faith of William and Catherine Booth, founders of the Salvation Army. Reverend Caughey's tombstone reads, "He that winneth souls is wise and he that turneth many to righteousness shall shine as the stars forever." (Courtesy of Robin Rowand.)

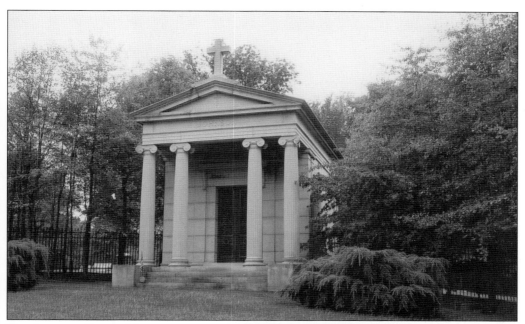

THE JOHNSON FAMILY MAUSOLEUM. In 1886, brothers Robert Wood Johnson, James Wood Johnson, and Edward Mead Johnson founded a small medical products company in New Brunswick, New Jersey. Their company would grow over the years to introduce the first aid kit, dental floss, Band-Aids, and Johnson's baby powder. Johnson & Johnson expanded over the years to worldwide prominence and included manufacturing and research facilities in North Brunswick. (Courtesy of Robin Rowand.)

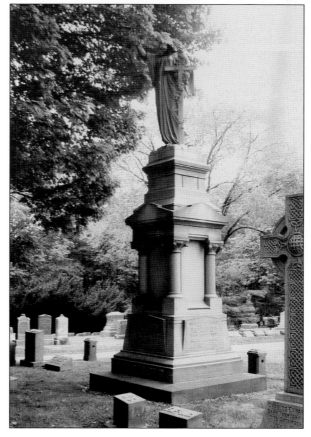

THE CARPENDER FAMILY BURIAL SITE. Jacob Stout Carpender (1805–1882) was a merchant and banker who settled in New Brunswick in 1852. His wife, Catharine Neilson Carpender (1807–1888), was a granddaughter of Brig. Gen. John Neilson, who gave the third public reading of the Declaration of Independence. Their sons' homes are still in use as administrative offices of Douglass College in New Brunswick. (Courtesy of Robin Rowand.)

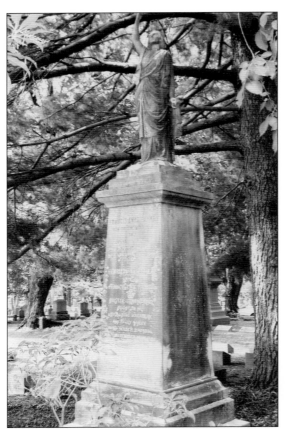

FRANCIS E. PARKER MEMORIAL.
Francis Parker (1857–1905) developed a neurological disorder requiring round-the-clock care. His final wish was that a home be built to provide treatment to those unable to afford it. His wife, Henrietta, opened the Parker Home two years later to care for chronically ill people. Local residents perked up when the home was mentioned in the television show *Mad Men* as a possible home for Betty Draper's father. (Courtesy of Robin Rowand.)

COOK FAMILY HEADSTONE. George Hammell Cook (1818–1889), was a professor of chemistry at Rutgers College. He was committed to the idea of scientific agriculture and lobbied to have Rutgers become a land grant college. Cook later became the first director of New Jersey's Agricultural Experiment Station. By 1914, the College of Agriculture was fully formed and in 1974 was renamed Cook College in his honor. (Courtesy of Robin Rowand.)

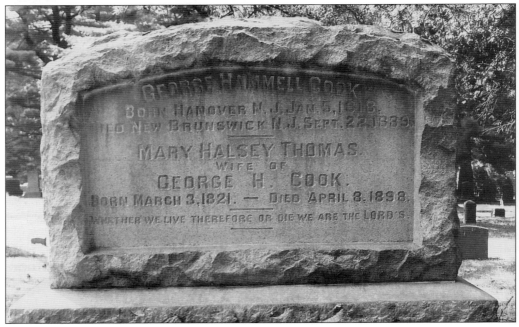

Four

TO SERVE AND PROTECT

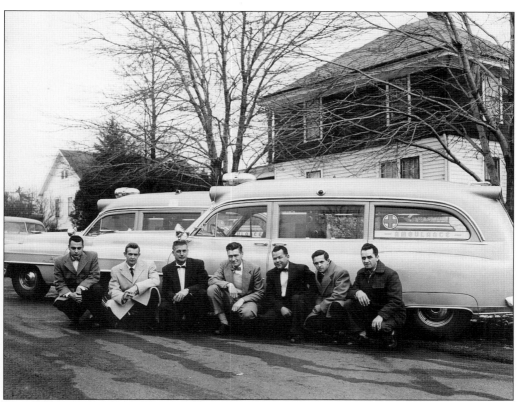

TO SAVE THE DAY. The North Brunswick First Aid and Rescue Squad (NBFARS) was founded by a group of men who decided the town needed its own volunteer ambulance service. Incorporated in 1955, it was an all-male organization. Seven of the founding members pose in front of their two used Cadillac ambulances: Harry Battaglia, James Wright, Burkhardt Wyckoff, Buck Pollard, Elmer Lepert, Bud Murphy, and Harry Brown. (Courtesy of the NBFARS.)

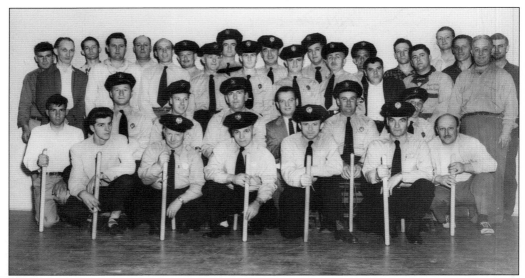

READY TO RUMBLE. The police department was organized in 1922 with William Hofer and Archer VanPelt making up the part-time force. Within three years, the department had grown to five men. Hofer was named chief in 1934 and held that position for 27 years. Carmen Canastra replaced him in 1962. Fears of juvenile delinquents and gangs led to a riot squad being established in the 1950s. This group was made up of part-time police officers and civilians, some of whom were neighborhood farmers. As demonstrated in these photographs, the volunteer members were not instructed on the proper use of firearms but were trained to defend the community with nightsticks. At that time, it was unheard of to have women volunteering for this type of duty. (Courtesy of the Canastra family.)

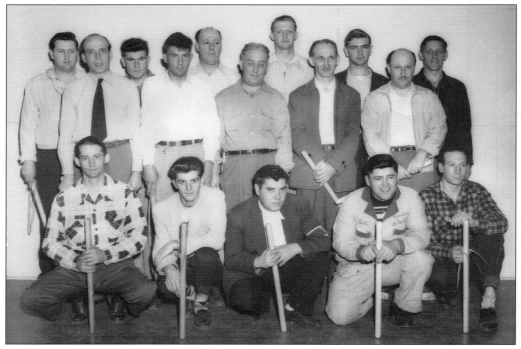

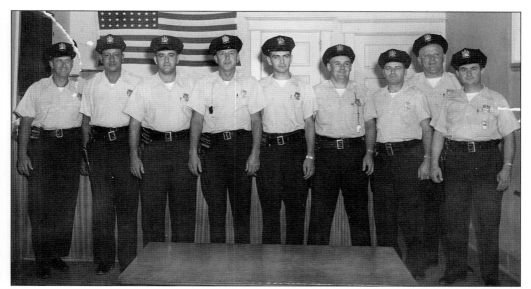

POLICE SPECIALS. The part-time policeman was rapidly becoming a thing of the past, and the officers posing here are seen in a meeting room on the second floor of Fire Company No. 1, which was used as police headquarters. In this photograph from the mid-1950s are, from left to right, Roland Applegate, Donald "Jack" Ralph, Joe Vigilante, James Wright, Jacob Hobschaidt, Bill Heinlin, unidentified, Tony Degotis, and Elmer Olchvary. (Courtesy of the Canastra family.)

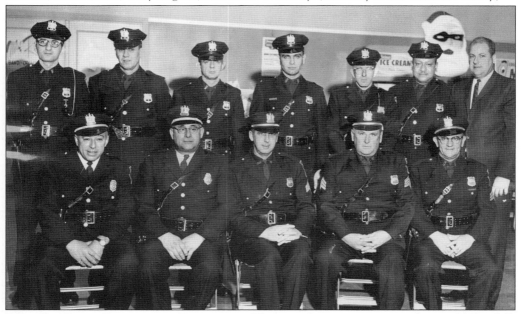

FULL-TIME POLICE DEPARTMENT ESTABLISHED. The township committee voted to establish a full-time police department in 1964. The force includes, from left to right, (first row) Chief Carmen Canastra, John Nastus, Roland Applegate, Stanley Weiss, and Willard "Bill" Myers; (second row) Anthony Vitanza, Jr., Stephen Smith, James Wright, Jr., Jacob Hobschaidt, Anthony Ingandela, Donald "Jack" Ralph, and John Flannagan, township committeeman and police commissioner. (Courtesy of the Canastra family.)

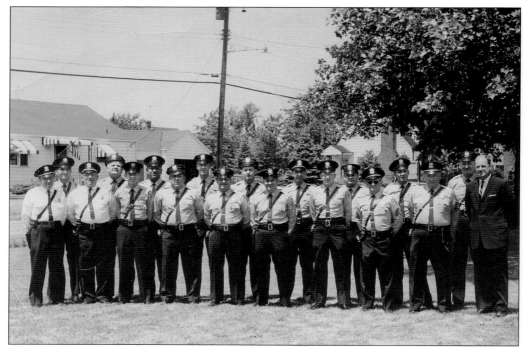

NORTH BRUNSWICK'S FINEST. Police commissioner Flannagan poses here with his police force on the lawn of the Municipal Building/North Brunswick Police Department on Linwood Place. Shown here in 1966 are, from left to right, Carmen Canastra, Antony Vitanze, Tony Nastus, Tony Degutis, Jim Wright, Jack Ralph, Bill Czarda, Theadore Stopinski, Mike Rispolli, Tony Capporatta, Ed Freiwald, Roland Applegate, Tony Ingadella, Burton Grenley, Willard Myers, Steve Smith, Stanley Weiss, George Salzman, and John Flannagan. (Courtesy of the Canastra family.)

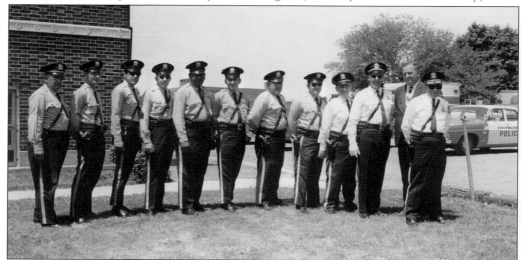

MEN IN BLUE. Police commissioner John Flannagan, police chief Carmen Canastra, and their officers pose proudly outside of the new police headquarters in 1968. The police department moved their headquarters into the basement of the 'new' municipal building on Hermann Road, which originally was the Parsons Elementary School. (Courtesy of the Canastra family.)

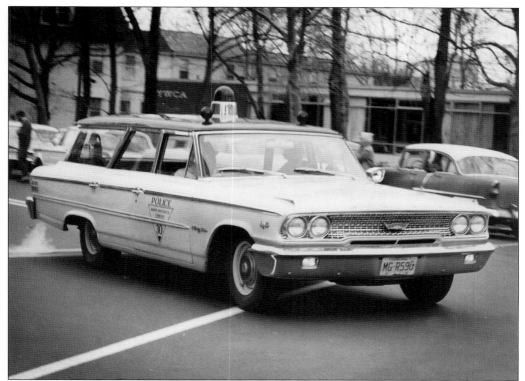

CRUISING DOWN THE AVENUE. Police chief Carmen Canastra and his driver are going to meet colleagues in New Brunswick in a 1963 Ford Galaxy. The number 30 on the side door more than likely refers to the number of vehicles owned by the township rather than the number of police cars on the force. In the early 1960s, the police department only had 10 full-time officers. (Courtesy of the Canastra family.)

IN THE LINE OF DUTY. Police chief Carmen Canastra and officer John Nastus were the occupants of this Ford patrol car when it was peppered with shotgun pellets from the gun of Butch Brown on January 2, 1953. Although details of this incident are unknown, the police officers involved were not injured. (Courtesy of the Canastra family.)

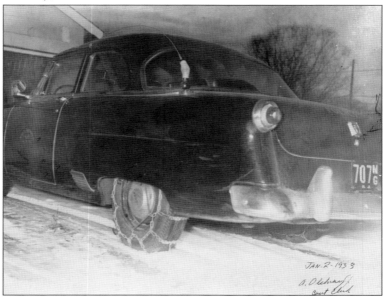

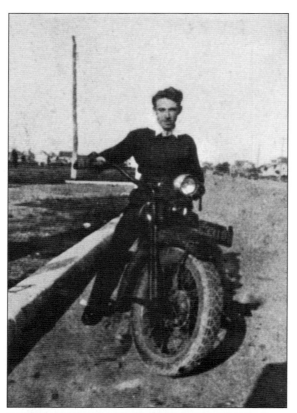

CYCLING ALONG. In his younger days, police chief Carmen Canastra poses on his motorcycle around 1940 in front of the future site of the New Brunswick High School on Livingston Avenue. At that time, soldiers and their families lived on that site in veterans housing. This complex was torn down in the early 1960s to allow for the construction of the high school. (Courtesy of the Canastra family.)

STOP THAT COW. Officer Stanley Weiss captures and returns a runaway cow. Judging by the look on the children's faces and the crowd that gathered, it appears as though this missing cow caused quite a stir in the early 1960s. Bessie, a Holstein, was returned safely to her farm by one of North Brunswick's finest. (Courtesy of the North Brunswick Police Department.)

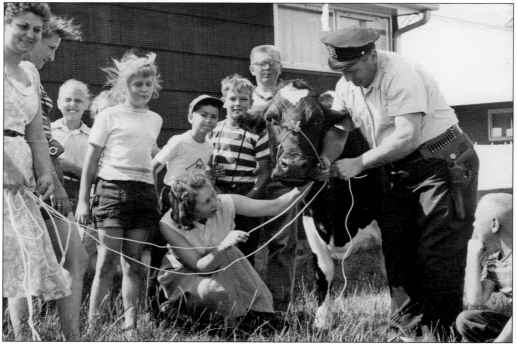

Big Wheels Keep on Turning. Patrolman Ralph Mulhern and Sgt. Donald Ralph are shown here helping Ken Applegate handle his vintage bicycle in 1968. This photograph was taken at police headquarters while Ken was getting a lesson in bicycle safety.

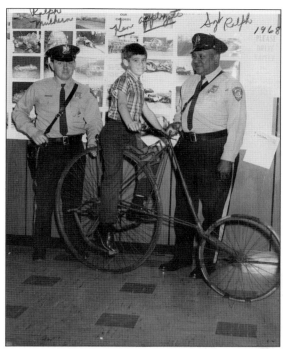

I Want to Ride My Bicycle. Students pedaled their way to Livingston Park School in 1969. Police officers observe as fourth graders Scott Bannier and Brian Eato show them how they perform routine bike maintenance. Judging by the number of cycles parked in this bike rack, it is fair to say that bicycling to school was the way to go. (Courtesy of Scott Bannier.)

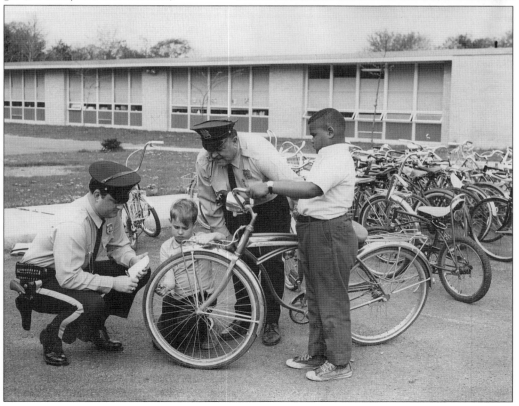

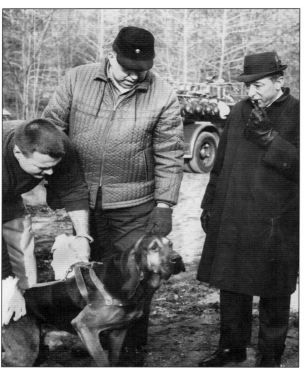

CSI North Brunswick. Shown in this mid-1960s photograph, Chief Carmen Canastra investigates a crime scene with the help of a police bloodhound named Gus. The chief and Middlesex County police personnel are about to set Gus loose to track down an escaped prisoner near the County Workhouse off Route 130 North. (Courtesy of the Canastra family.)

Police on Patrol. With a more mobile population and most families having a car, shopping trends changed with the development of a strip shopping center on the corner of Georges and Milltown Roads, where once there was an orchard. Ample free parking was available as was police protection. Lt. Jim Wright stands on guard at the entrance of the Brunswick Shopping Center in 1958. (Courtesy of the North Brunswick Police Department.)

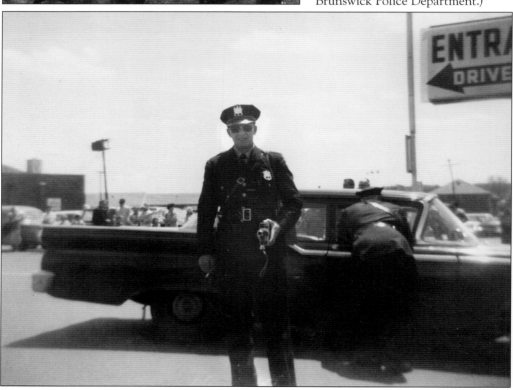

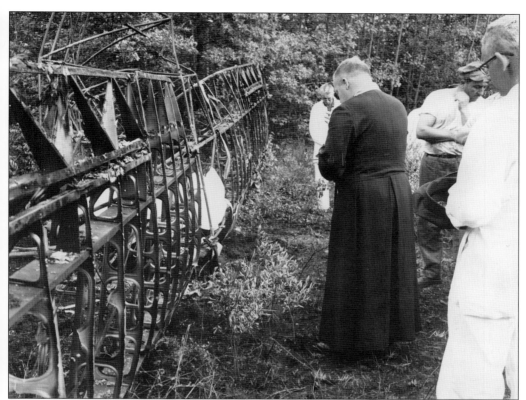

AIRPLANE CRASH IN NORTH BRUNSWICK. All that remains of the North Brunswick Airport is a street named Airport Road. From 1947 to the early 1960s, this was an active airfield for private planes and flying lessons. With money from the GI Bill, the Aeromotive Corporation, made up of Walt Gingrich, Runyon Van Syckle, Pete Peterson, and Mr. Jensen, started the airport on the Van Syckle Farm between Jersey Avenue and Route 27 near How Lane. The airport eventually grew to have three grass-covered runways, hangars, and a control tower. In the mid-1950s, residents were shocked by the accidental death of one of the owner's sons, who had recently received his solo license and was out practicing when the single-engine plane crashed and burned in the nearby woods.

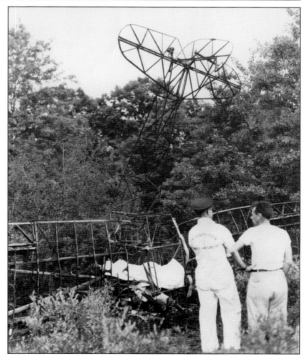

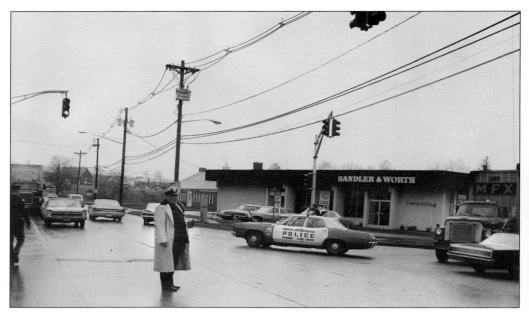

SLIPPERY WHEN WET. Here on the corner of Georges and Hermann Roads, several police officers gather to maintain traffic flow after a traffic accident involving one car. Over the left shoulder of the police officer, quite a bit of open space is visible in the early 1970s in the now built-up Berdine's Corner section of town. (Courtesy of the North Brunswick Police Department.)

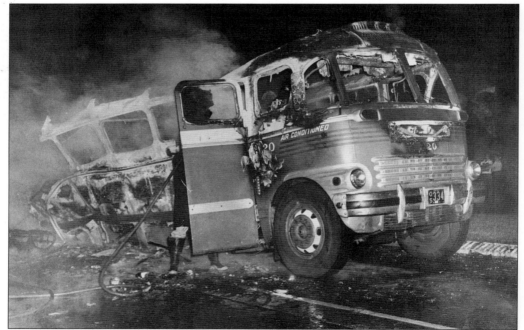

BUS CRASH ON ROUTE 1. A shell was all that remained following a tragic collision between a bus and an oil tanker at the intersection of Ryders Lane and Route 1 that killed 11 Trenton State College students and their teacher in 1959. The accident produced pressure for the state to eliminate the traffic signal at that point and construct an overpass. (Courtesy of the Canastra family.)

FIRE COMPANY NO. 1. On March 31, 1925, the following residents of North Brunswick Township met at the Men's Club of Berdine's Corner and signified their willingness to and resolved forthwith "to form a company for the prevention of loss of life and property by fire, to the residents of North Brunswick Township." They were Cecil Arnett, Alvin Flavell, Harold F. Glines, M. W. Huston, Al Hofer, Raymond Hunt, John Hunt, Charles Nobel, Marcel Renson, Farrell Smith, Edward Smook, George Sweimler, Harold Vanderwater, Arch VanPelt, Charles VanPelt, Jim Voorhees, William Voorhees, Gus Weinman, George Whittle, and John Zabadick. A carnival to raise funds was held that June, and Mrs. John Van Deursen, president of the Thimble Club, was thanked for the donation of a quilt for chancing. The Fire Company No. 1 firehouse was built in 1932 on Maple Avenue at the cost of $11,000. At a meeting in 1932, a motion was passed to "rent the upstairs meeting room for dances, card parties, and meetings at the rates of dances, $10; card parties, $3; and club meetings, $3." (Courtesy of Fire Company No. 1.)

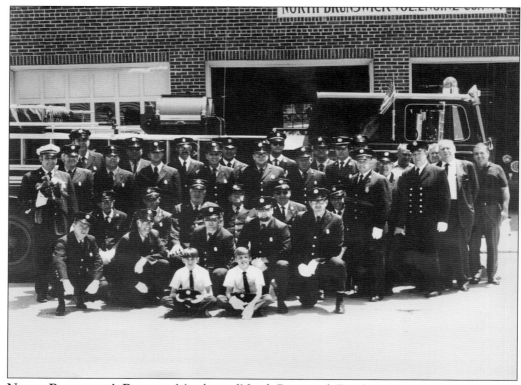

NORTH BRUNSWICK'S BRAVEST. Members of North Brunswick Fire Company No. 1 wearing their dress uniforms pose proudly for this picture outside of the firehouse on Maple Avenue in the early 1970s. Large modern fire trucks were difficult to maneuver through the narrow residential streets of Berdine's Corner, and a new firehouse was built near the Route 1/Route 130 intersection in 1990. (Courtesy of Fire Company No. 1.)

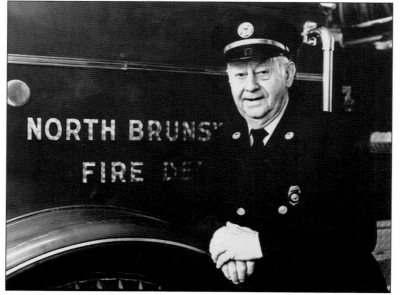

FOUNDING FATHER. Paul "Pappy" Bannier was at a Maple Meade Men's Club meeting when fire broke out at the Applegate Brothers Garage. He hopped in his 1925 Ford and rushed to the new Berdine's Corner Fire Company to sound the alarm. This crosstown trip proved the need for a fire company in the Maple Meade area. (Courtesy of Fire Company No. 2.)

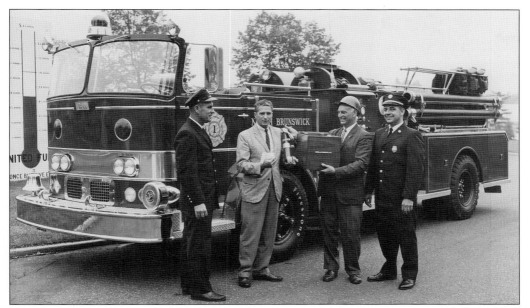

Fund-Raising Efforts. Volunteer fire departments need funds to survive, and these local businessmen helped to raise revenue for Fire Company No. 1 in the mid-1960s. Fire Company No. 2 solicited funds from passing motorists on Old Georges Road. If not for Judge Shepperd, a member of the fire company, smoothing over motorists' complaints, Firehouse No. 2 might have taken twice as long to build.

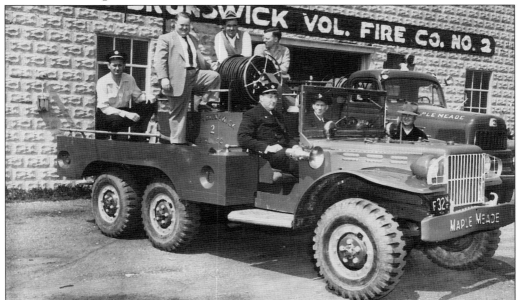

The Start of Fire Company No. 2. On January 11, 1926, Engine Company No. 2 of Maple Meade was formed with approximately 43 members. For a token price, Mr. and Mrs. Thomas Buckelew sold a piece of property adjacent to the Applegate Brothers Garage for the new firehouse. Shown here in 1955 are, from left to right, George Salzmann, Dyke Pearce, Al Rupreck, Marshall Pierce, Steve Skaritka, Ross Reed (in the driver's seat), and unidentified. (Courtesy of Fire Company No. 2.)

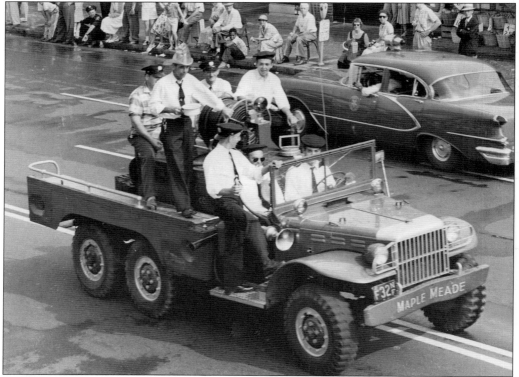

Fun in Atlantic City. Spectators along a parade route in Atlantic City in 1957 might expect to get wet when Fire Company No. 2 goes by. Playfully getting ready to cool off the crowd are Ray Hilliard, Bob Golding, Al Dickerman, James Loughlin, Frank Guyette, and Henry Schipmann. (Courtesy of Fire Company No. 2.)

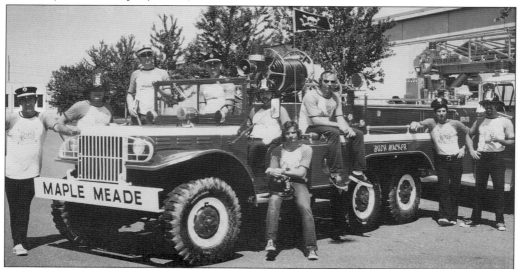

Sons of the Bush Wackers. The next generation of volunteers poses for a picture in front of their "Bush Wacker" truck. White shirts, ties, and backwards hats give way to matching T-shirts, jeans, and pirate flags in the 1970s. (Courtesy of Fire Company No. 2.)

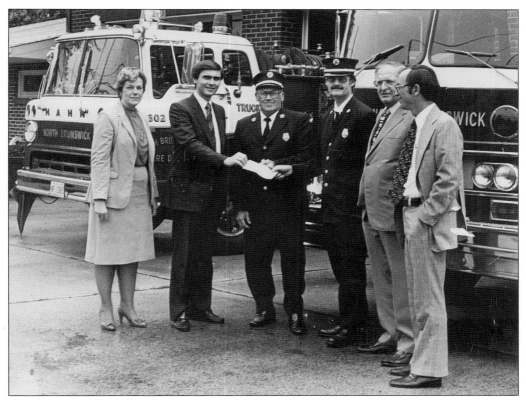

FIRE COMPANY NO. 3. Founding members placed an advertisement in a local newspaper asking for volunteers interested in starting a fire company for the Route 27 section of town. The founding group met to plan at the Fairlawn Inn on Route 27. The company was made official in 1959 with the following men as members: Joseph Brill, Mike Lacik, Frank Scordo, Robert Heuer, Tony Tavalare, Thomas Eckert, Matt Witkowski, Jack Shaughnessy, Ray Criss, Warren Eckert, Charles Bohoboy, Harold Boyer, Richard Ungerbuller, and Vincent Covino. The first fire on record was a field blaze in the Pardun Woods on Route 130 on January 30, 1962. Shown above in 1981, Chief Joe Brill and Rick Carmen accept a donation from executives of Johnson & Johnson. Standing at attention in the photograph below are original members of Fire Company No. 3 in 1960. (Courtesy of Fire Company No. 3.)

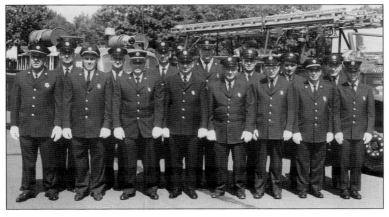

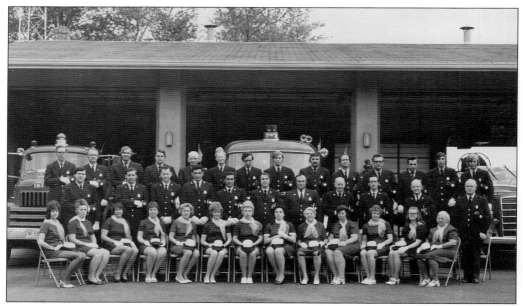

DEDICATION AND WET DOWN. Members of Fire Company No. 2 and the ladies auxiliary pose for a portrait on June 17, 1972. Besides commemorating a new building, they celebrated a new truck. A truck was damaged during the famous fire at the A&P store in 1968. A 1972 Ford with a 50-foot ladder and custom-built body was wet down on the same day. (Courtesy of Fire Company No. 2.)

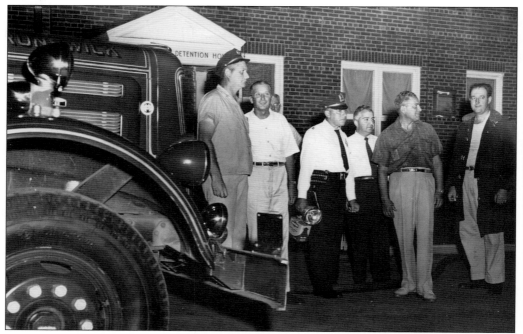

CALLING 911. Members of the police and fire departments respond to a fire call at the Middlesex County Detention Home for Boys in the mid-1950s. North Brunswick has hosted the detention facilities for youths and adults since the early 1950s. (Courtesy of the Canastra family.)

FUN AT THE FIREHOUSE. Members of Fire Company No. 1 perform at their Class Room Variety Show in 1954. Pictured here are Joe Rosenburg, Jack Nowitkze, Mr. Kaplan, and George Long. Minutes from the meeting prior to the show reported that things for this event "were going smoothly but that they needed more firemen for the chorus." (Courtesy of Fire Company No. 1.)

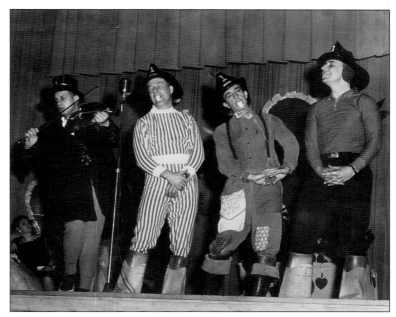

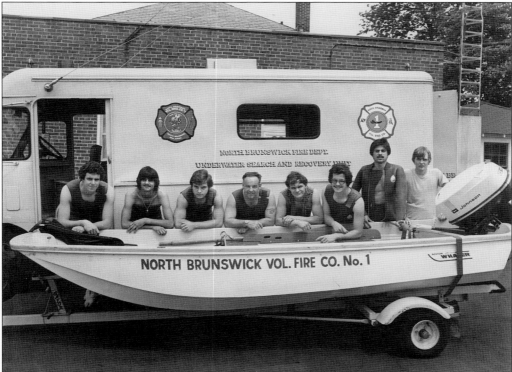

WATER RESCUE UNIT. Pictured here in the mid-1970s are members of Fire Company No. 1's water rescue unit. They are, from left to right, Mark Cafferty, Mike Vitanza, George Mayer, Tom Irwin Sr., Bert Mezzerole, Brian Cafferty, George Coco, and Jimmy Warger. (Courtesy of Fire Company No. 1.)

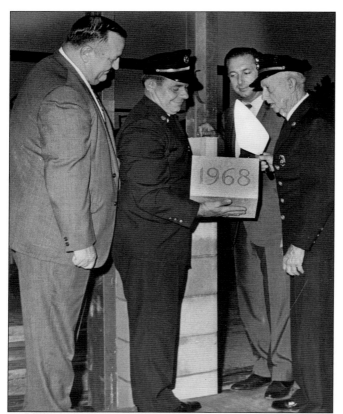

CORNERSTONE LAID. In 1950, land was purchased for a new firehouse for company No. 2. Mrs. Henry Miller sold her property behind the original firehouse for a nominal fee. In 1967, a building committee was formed with former chief Frank Guyette as chairman, and by 1968 building was underway. In this photograph are, from left to right, Mayor Rupprecht, Walter Lapp, committeeman Jack Pincus, and Pappy Bannier. (Courtesy of Fire Company No. 2.)

MEMORIAL ON LIVINGSTON AVENUE. Opposite the post office on Livingston Avenue stands a special memorial to the town's volunteer fire department members. It was dedicated in 1988. Every year on Memorial Day, a service is held in tribute to these brave men who selflessly protect the community.

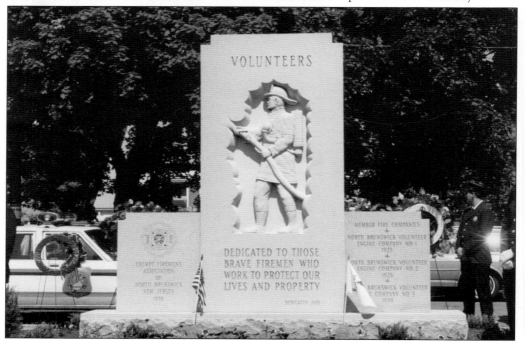

Five

NORTH BRUNSWICK MEANS BUSINESS

GOETZE GASKET AND PACKING COMPANY. The Condren Corporation was established in 1887 on Nassau Street as the Goetze Company, a manufacturer of gaskets. The product was used in the building of the Lincoln Tunnel. In 1947, the Goetze Company was purchased by the Johns Manville Corporation and 28 years later was bought by Donald Condren, senior vice president.

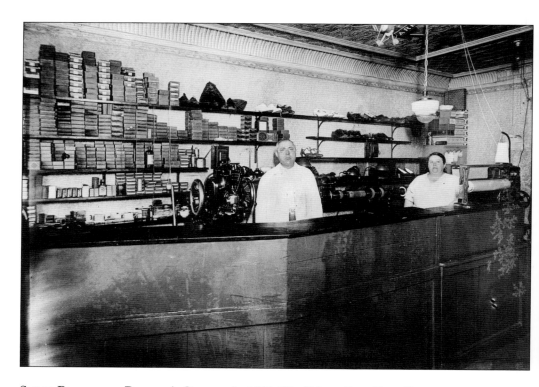

SMALL BUSINESS IN BERDINE'S CORNER. In 1926, "Fred Nigro First Class Shoe Repairing" offered expert workmanship, guaranteed work, prompt service, and reasonable prices in a shop located in the Berdine's Corner section of town. At the intersection of Georges and Milltown Roads, it was a North Brunswick business rather than New Brunswick as noted on Nigro's business card. New Brunswick and North Brunswick were frequently used interchangeably as addresses as the North Brunswick Post Office was a branch of the New Brunswick Post Office.

FIRST CLASS
SHOE REPAIRING

All work receives the best of attention in my *new and full equipped Shoe Repairing Shop. Expert Workmanship. Prompt in Service. Prices Reasonable.* ALL WORK GUARANTEED.
GIVE US A TRIAL AND COVINCE YOURSELF

FRED. NIGRO

at BERDINES CORNER NEW BRUNSWICK, N. J.
BOX 1117

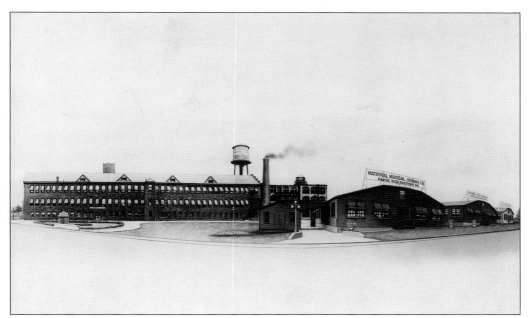

NATIONAL MUSICAL STRING COMPANY. The National Musical String Company shown in these pictures taken in 1929 is one of the best photographically documented industries in the history of North Brunswick. Besides producing strings for guitars, banjos, violins, and mandolins, it also produced guitar picks, with its Black Diamond brand being the best known. In 1979, the company was renamed the Caman Musical String Company and relocated to Connecticut. In the picture below, men are working to print boxes to package the products.

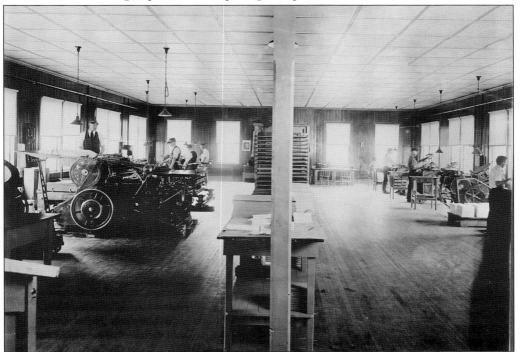

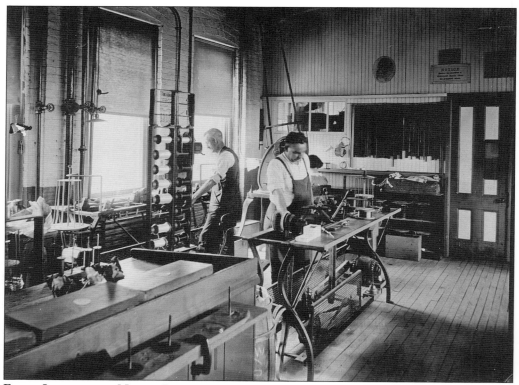

EARLY INDUSTRY IN NORTH BRUNSWICK. The National Musical String Company's spooling department in 1929 was staffed by men, and the coiling department was staffed by women. Coiling was done entirely by hand, which took advantage of women's smaller, more dexterous hands. The modern factory was well lit and ventilated sufficiently in a time period predating air-conditioning.

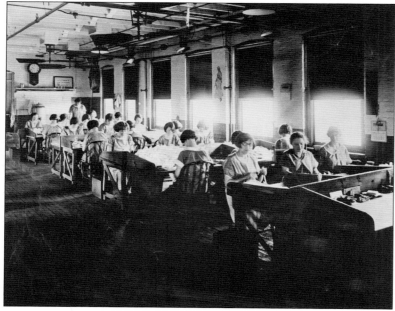

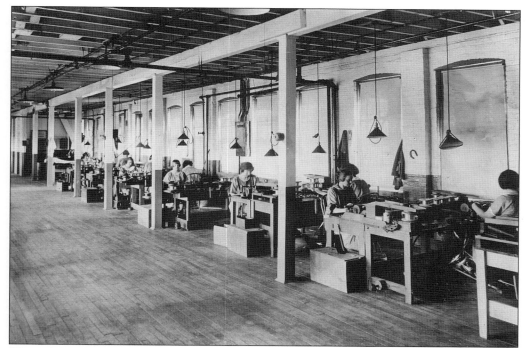

WOMEN'S WORK IS NEVER DONE. Female employees of the National Musical String Companies loop strings in this picture taken in 1929, and the final product is packaged in the packing department for shipping. These pictures taken by the Van Derveer Studios in New Brunswick serve as a wonderful pictorial history of typical pre–World War II industry in Central New Jersey.

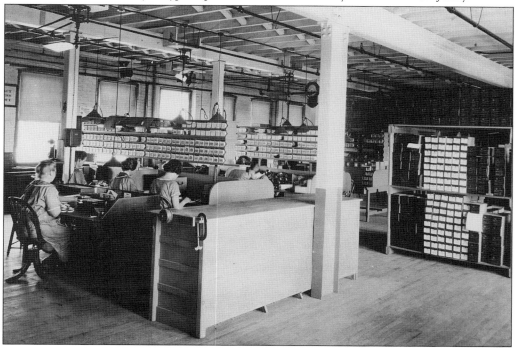

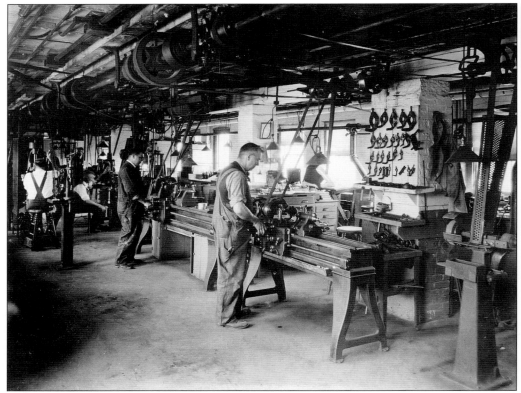

OFF TO WORK WE GO. Men worked in the machine shop of the National Musical String Company and drove the trucks to deliver their products to stores throughout New Jersey. Careful observation of the trucks shows the address is listed as New Brunswick rather than North Brunswick, but there is no doubt that the factory was located in North Brunswick.

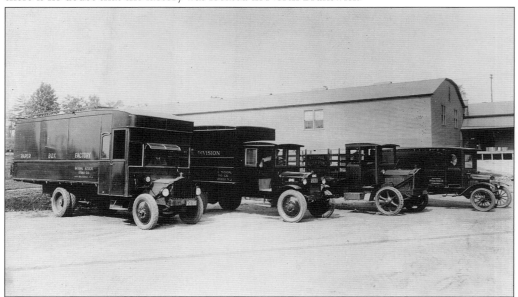

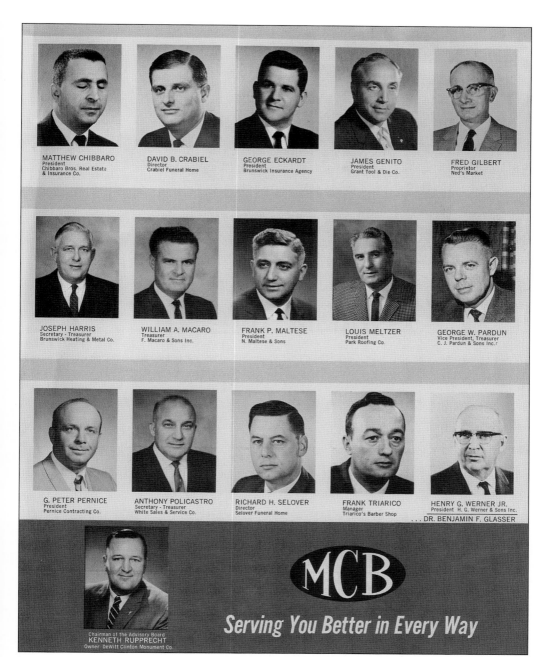

MATTHEW CHIBBARO
President
Chibbaro Bros. Real Estate
& Insurance Co.

DAVID B. CRABIEL
Director
Crabiel Funeral Home

GEORGE ECKARDT
President
Brunswick Insurance Agency

JAMES GENITO
President
Grant Tool & Die Co.

FRED GILBERT
Proprietor
Ned's Market

JOSEPH HARRIS
Secretary - Treasurer
Brunswick Heating & Metal Co.

WILLIAM A. MACARO
Treasurer
F. Macaro & Sons Inc.

FRANK P. MALTESE
President
N. Maltese & Sons

LOUIS MELTZER
President
Park Roofing Co.

GEORGE W. PARDUN
Vice President, Treasurer
C. J. Pardun & Sons Inc.r

G. PETER PERNICE
President
Pernice Contracting Co.

ANTHONY POLICASTRO
Secretary - Treasurer
White Sales & Service Co.

RICHARD H. SELOVER
Director
Selover Funeral Home

FRANK TRIARICO
Manager
Triarico's Barber Shop

HENRY G. WERNER JR.
President H. G. Werner & Sons Inc.
... DR. BENJAMIN F. GLASSER

Chairman of the Advisory Board
KENNETH RUPPRECHT
Owner DeWitt Clinton Monument Co.

MCB
Serving You Better in Every Way

NORTH BRUNSWICK BUSINESSMEN. The Middlesex County Bank Advisory Board in 1966 was composed of 17 successful North Brunswick businessmen who formed an advisory board and contributed their personal expertise to various areas the bank served. The financial institution, located at 575 Milltown Road, is the next-door neighbor to the now long gone Bodine house, where Samuel Stillman's wagon was hit by a trolley. The building continues to serve as a bank today.

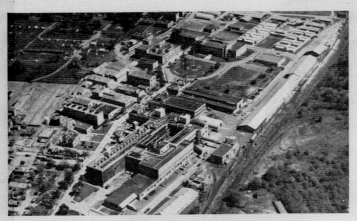

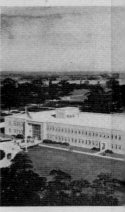

E. R. SQUIBB & SONS

NATIONAL HEAD

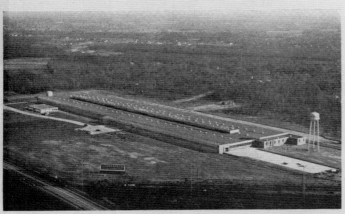

THE EASTERN ASSEMBLY PLANT OF STUDEBAKER CORPORATION

PERSONA

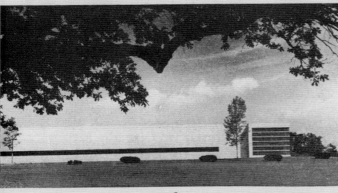

ETHICON SUTURES

INDUSTI

North Brunswick prides itself on havi
industrial plants in the Country. The i
national attention for their attractiven
New Jersey Garden Club prize as the

Industries are diversified. However, t
sion of Olin Mathieson Chemical Cor
and Carter Products, Inc. manufacture
include National Musical String Corpe
Pepsi-Cola Bottling Company, Rodic
Rand, Inc., The Eastern Assembly Pl
Servall Paper Box Company, Herman
Uniman Printers and the Alexander S

NORTH BRUNSWICK, A GOOD PLACE TO LIVE AND WORK. An advertisement from 1955 entices

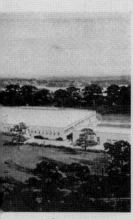

OUTS OF AMERICA

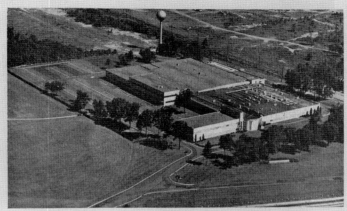

PERMACEL TAPE

ORATION

GOETZE GASKET, BRANCH OF JOHNS-MANVILLE PRODUCTS

OPMENT

modern and architecturally fascinating
cated on U. S. Route #1 have received
Permacel Tape has been awarded the
the State.

e up of E. R. Squibb and Sons, Divi-
res, Personal Products, Permacel Tape,
her industries located in the township
t, branch of Johns-Manville Products,
Corporation, subsidiary of Remington
orporation, Graybar Shipping Center,
y, New Brunswick Cooperage Works,
Shipping Center.

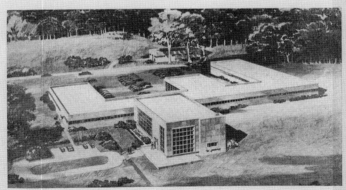

JOHNSON & JOHNSON RESEARCH CENTER

industry to move to North Brunswick.

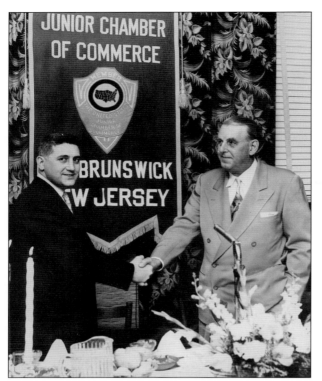

MAN OF THE YEAR. Fred Hermann, long-term mayor, congratulates junior chamber of commerce member Frank Maltese on his award as Man of the Year for 1957. The Maltese family owned N. Maltese and Sons, a steel fabrication business which is still operational on Jersey Avenue.

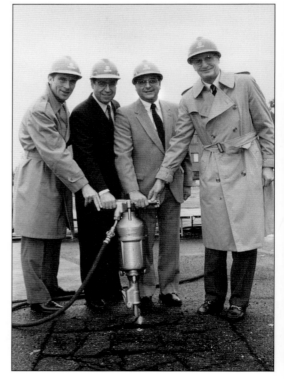

BRISTOL-MYERS SQUIBB BREAKS GROUND. Among the first firms to locate in North Brunswick in the early 20th century was E. R. Squibb and Sons in 1905. Breaking ground in the early 1980s for a new Employee Services Building are, from left to right, Jan Leschly, Squibb Corporation executive vice president; Dr. Louis T. DiFazio, president, Squibb Technical Operations; North Brunswick mayor Paul Matacera; and Richard M. Furlaud, Squibb Corporation chief executive officer.

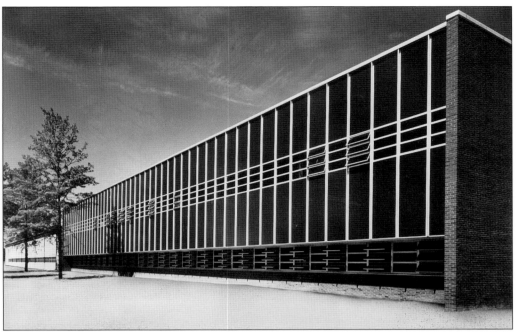

MODERN INDUSTRY IN NORTH BRUNSWICK. The Johnson & Johnson Eastern Surgical Dressings Plant, opened in 1957, was the site of the corporation's annual meetings from 1957 to 1964. The clean architectural lines of Johnson & Johnson's new building are emphasized in this view of the maintenance wing, finished with blue enamel steel cover plates and white trim. There were five buildings on the 300-acre site for a total of 630,000 square feet. Pictured below is the baby products building, which opened the same year. It is situated behind a 900-foot reflection pool that served as a ready water supply for emergencies as well as an attractive landscaping feature.

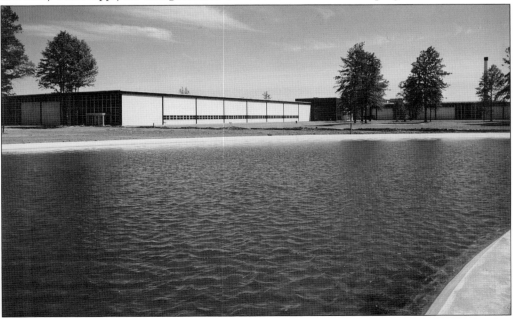

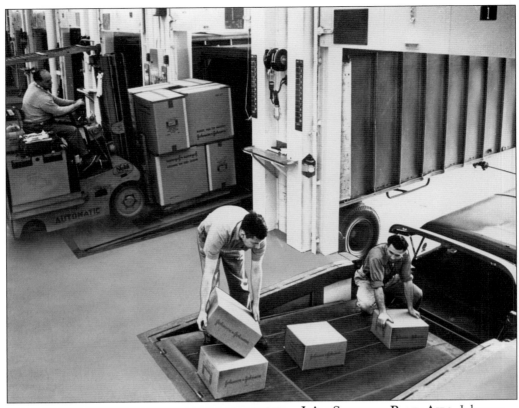

I Am Stuck on Band-Aids. Johnson & Johnson products, including Band-Aids and baby powder, were shipped from the 23 four-way adjustable loading docks that conformed to any size truck. This was a major advance in 1957 for warehouse operations. The dock on the right has been lowered to fit a station wagon while the one on the left has been raised to the height of a tractor trailer.

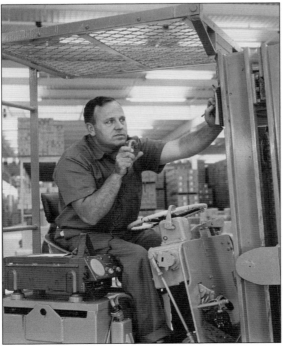

Band-Aids Are Stuck on Me. In 1957, all forklift trucks in the sprawling Johnson & Johnson shipping center were equipped with two-way radios enabling drivers to contact the stock control center for instructions.

DYING TO GET IN. The photograph above depicts 555 Georges Road as it looked in 1964. Originally this property was occupied by a large Victorian house and a beverage distributing company. The house and business were torn down in 1964 to make way for the Selover Funeral Home (pictured below), which opened in February 1965. Adjacent to the funeral home is the Van Liew Cemetery and just up the road is the Elmwood Cemetery. (Courtesy of the Selover family.)

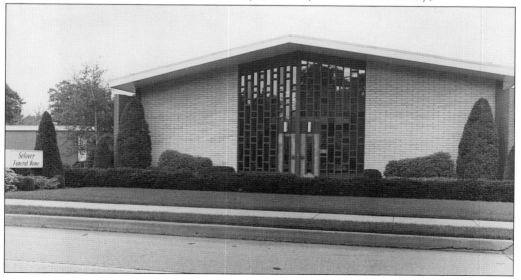

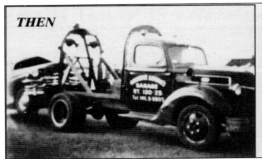

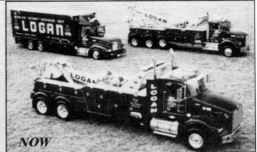

ACCIDENTS CAN HAPPEN. The George Logan Towing Company was founded in 1950 by George E. Logan Jr. and his wife, Rosemarie. They started with only one wrecker that had a hand-cranked winch and a wooden box of tools. Today Logan's Services include tractor and trailer rollover recovery, a hazmat cargo tank truck specialty, and four-by-four off-road recovery wreckers.

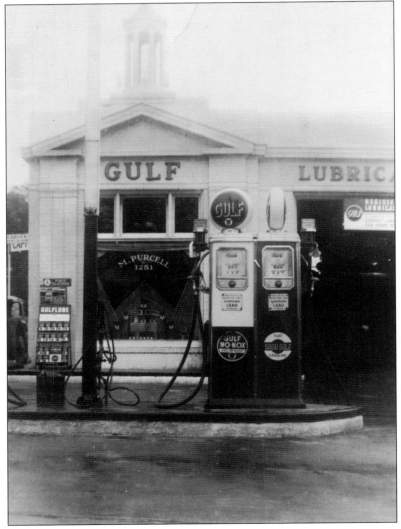

JERSEY GIRLS DON'T PUMP GAS. M. Purcell's Gulf station stood on the corner of Georges Road and Nassau Street. In this photograph taken during the 1920s, the phone number appearing under Purcell's name is 1251. This property still contains a gas station today, albeit with modern-day gas pumps.

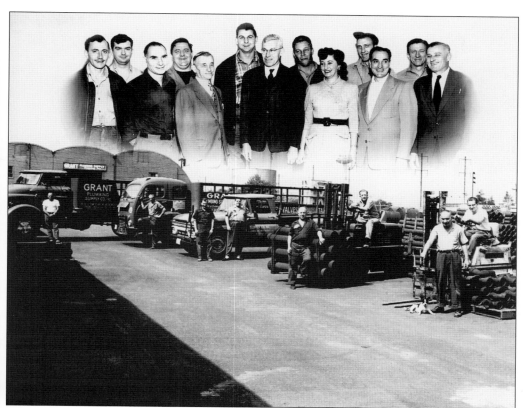

GRANT PLUMBING SUPPLY COMPANY.
Founded in 1933 by Edward C. Lefebvre, this family-owned business distributed its products to local plumbing contractors. Many of Grant's original customers from the 1930s are current active accounts being served by second and sometimes third generation family members. The scope of the business has broadened over the years to include large commercial projects such as the Jets Training Camp and the new Giants Stadium.

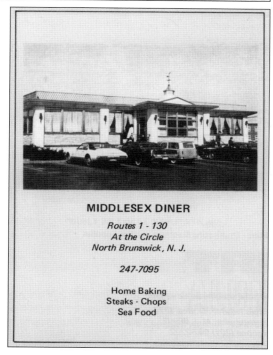

MIDDLESEX DINER

Routes 1 - 130
At the Circle
North Brunswick, N. J.

247-7095

Home Baking
Steaks · Chops
Sea Food

WHAT WILL YA HAVE, HON? The Middlesex Diner shown in this advertisement from 1973 was a favorite meeting place for people far and wide. When the Route 1 and Route 130 traffic circle was redesigned into the current bridge configuration in the early 2000s, the diner was sold, picked up, and relocated down the shore.

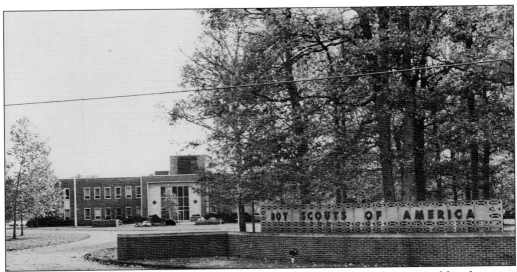

BE PREPARED. From 1954 until 1979, North Brunswick was home to the national headquarters of the Boy Scouts of America, located just south of the intersection of Routes 1 and 130. Shown in this photograph is the entrance to the building, with a statue of an early Boy Scout and the famous motto "Be Prepared." The site also held the Johnston Historical Museum (not pictured here), depicting the history of Scouting, which was dedicated on June 4, 1960. The museum was relocated to Irving, Texas, along with the national headquarters in 1979.

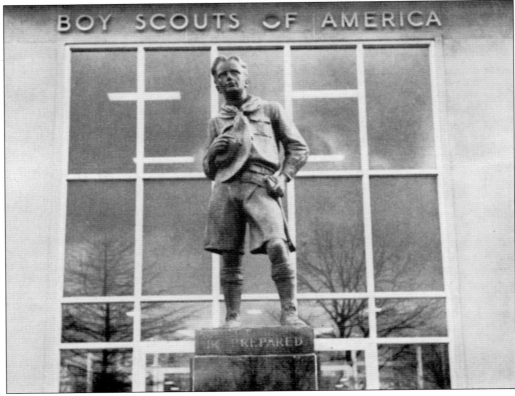

Six

LOCAL POLITICS

NORTH BRUNSWICK UNION TICKETS.
For most of the 19th century, political parties controlled the printing and distribution of paper ballots, also known as party tickets. State election laws specified the thickness of the paper and the size of type to be used. The rest was left to the issuing parties and candidates. This resulted in all types of styles and the potential for confusion and fraud.

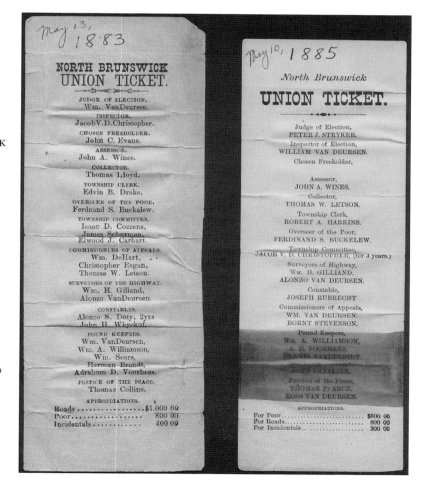

May 13, 1883

NORTH BRUNSWICK UNION TICKET.

JUDGE OF ELECTION.
Wm. VanDeursen.
INSPECTOR.
Jacob V.D. Christopher.
CHOSEN FREEHOLDER.
John C. Evans.
ASSESSOR.
John A. Wines.
COLLECTOR.
Thomas Lloyd.
TOWNSHIP CLERK.
Edvin B. Drake.
OVERSEER OF THE POOR.
Ferdnand S. Buckalew.
TOWNSHIP COMMITTEE.
Isaac D. Cozzens,
James Schurman,
Elwood J. Carhart.
COMMISSIONERS OF APPEALS.
Wm. DeHart,
Christopher Regan,
Thomas W. Letson.
SURVEYORS OF THE HIGHWAY.
Wm. H. Gilland,
Alonzo VanDeursen.
CONSTABLES.
Alonzo S. Doty, 2yrs
John H. Whyckof.
POUND KEEPERS.
Wm. VanDeursen,
Wm. A. Williamson,
Wm. Sears,
Herman Brandt,
Adraham D. Voorhees.
JUSTICE OF THE PEACE.
Thomas Collins.
APPROPRIATIONS.
Roads $1,000 00
Poor 800 00
Incidentals 400 00

May 10, 1885

North Brunswick UNION TICKET.

Judge of Election,
PETER J. STRYKER.
Inspector of Election,
WILLIAM VAN DEURSEN.
Chosen Freeholder,

Assessor,
JOHN A. WINES.
Collector,
THOMAS W. LETSON.
Township Clerk,
ROBERT A. HARKINS.
Overseer of the Poor,
FERDINAND S. BUCKELEW.
Township Committee,
JACOB V. D. CHRISTOPHER, (for 3 years.)
Surveyors of Highway,
Wm. H. GILLIAND.
ALONZO VAN DEURSEN.
Constable,
JOSEPH RUBRECHT.
Commissioners of Appeals,
WM. VAN DEURSEN.
BORNT STEVENSON.
Pound Keepers,
WM. A. WILLIAMSON,
A. D. VOORHEES.
DENNIS VANDERBILT.
JOHN CAVALIER.
Justices of the Peace,
THOMAS PIERCE,
ROSS VAN DEURSEN.
APPROPRIATIONS.
For Poor $800 00
For Roads 800 00
For Incidentals 300 00

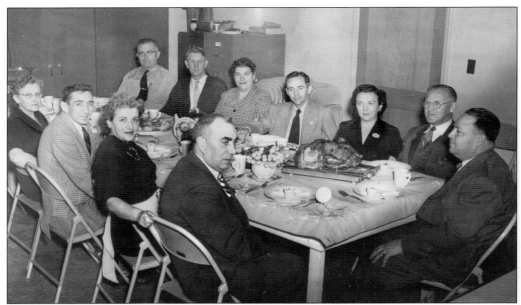

LET'S TALK TURKEY. Members of the North Brunswick Republican Social Club break bread together and celebrate an early Thanksgiving in 1953. Pictured clockwise from top left are Bill Hofer, Nelson Birch, Caroline Christ, Bob Frantz, Margaret Borton, George Frisch, Vincent Darago, Frank Florenz, Anna Wasserman, Alex Olchvary, and Inez Angell.

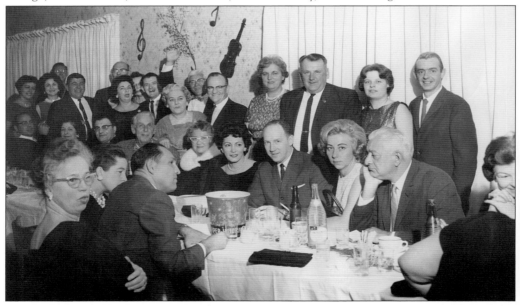

A 1963 VICTORY CELEBRATION. A political victory celebration is attended by, from left to right, Mr. and Mrs. Joseph Georgianni, Mr. and Mrs. Tony Comparato, Adelbert Czarda, Mr. and Mrs. Ray Amerman, Mr. and Mrs. Edwin Rebenald, Tony Canastra, Mr. and Mrs. Willard Myers, Mr. and Mrs. Stan Weiss, Mr. and Mrs. Jim Wright, Mr. and Mrs. Mike Rispoli, Mr. and Mrs. Fred Hermann, Mr. and Mrs. Gus Kuhlman, Mr. and Mrs. Moe Roth, Mrs. Ken Rupprecht, Mr. and Mrs. George Luke, and Josie Kortaba.

NORTH BRUNSWICK TOWNSHIP POINTS WITH PRIDE TO THE ELECTED OFFICIALS WHO SO ABLY AIDED IN THE ADVANCEMENT OF THIS COMMUNITY 1946-1955

PETER W. HUNT
Committeeman

FRED J. HERMANN
Mayor

VINCENT L. DARAGO
Committeeman

GEORGE C. FRISCH
Committeeman

CHARLES A. BORTON
Committeeman

JOSEPH M. DE HART
Committeeman

CHARLES KERN
Committeeman

ISAAC V. WILLIAMSON
Tax Assessor

GEORGE W. DAVIS
Tax Collector

Over the past decade the Township of North Brunswick has grown rapidly, both in population and stature. Municipal services for its citizens have been expanded to meet many needs as this growth occurred. We have adequate schools for our increasing number of younger residents. *Good schools!* We have good roads, police and fire protection, and improved legislation to protect the health and property of our taxpayers. Capable government during these progressive years has made North Brunswick one of the most attractive communities in the county — and at a low cost to its taxpaying inhabitants.

POLITICAL ACHIEVEMENT FLYER. North Brunswick mayor Fred Hermann and council members highlight their achievements to the community—specifically in the areas of schools, police, fire, health, and property taxes—in this featured community flyer from the early 1950s. North Brunswick's form of government was that of a township committee in which a mayor was appointed from the ranks of the committeemen. In later years, the form of government changed to a mayor and council format, in which the mayor is elected directly by the residents of the township. Fred Hermann was both appointed and elected mayor.

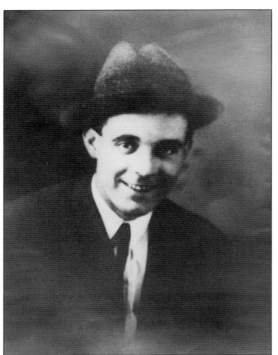

NORTH BRUNSWICK TOWNSHIP COMMUNITY LEADER. Pictured here is Thomas Corrigan, a North Brunswick township committeeman in the year 1931. Later Corrigan served as township chairman (mayor) in 1933.

PRE-ELECTION DAY RALLY. North Brunswick residents attend a "Continued Good Government" rally honoring Rupprecht, Swanson, and Kulhman in October 1960. Featured in this photograph are, from left to right, (first row) Joe Georgianna, Bob Bonamarte, Jack Ingadela, Mrs. Steinfeld, unidentified, and Carrie Kahlfield; (second row) two unidentified, Jake Giocalne, Vic Steinfeld, Mary Benanti, Jim Auchincloss, Grace Rispoli, and unidentified; (third row) Joe DeHart, unidentified, Bill Hofer, George Frisch, Bob Frantz, and Charles Kern.

LET'S MAKE A DEAL. Mayor Fred Hermann and union leader James Hoffa are pictured here discussing how the Township of North Brunswick and workforce laborers can form a perfect partnership together. This photograph was taken on the reviewing stand at the Memorial Day parade in 1962. Traditionally the reviewing stand on the parade route was located on the corner of Livingston Avenue and Hermann Road.

NORTH BRUNSWICK—OPEN FOR BUSINESS. At a United Delco event, Mayor Fred Hermann addressed the importance of local economic development in the township of North Brunswick. Fred Hermann served North Brunswick as mayor from 1946 through 1964.

NORTH BRUNSWICK ATTRACTS SMALL BUSINESSES. Township employees celebrate the opening of a new local business and welcome it to the North Brunswick business community. Featured in this 1969 photograph are, from left to right, Carmen Canastra, Edna Swanson, an unidentified business owner, June Helmetze, Marge Kikelhan, and another business owner who cannot be identified.

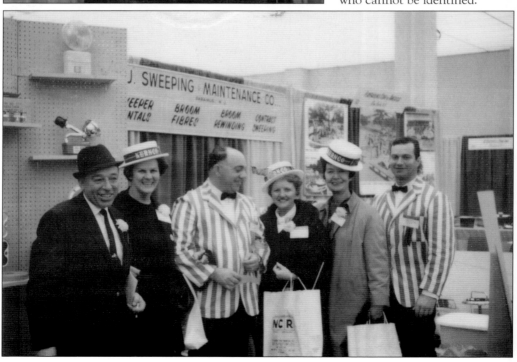

Picnicking in the Park. Local politicians and affiliates congregate in beautiful Babbage Park and pose on a rock for a picture while enjoying some freshly grown corn on the cob from a local North Brunswick farm. Pictured here in the early 1960s are, from left to right, Gus Kuhlman, Sam Mento, Ken Rupprecht, and Fred Gilbert.

19 65

TOWNSHIP COMMITTEE

George W. Luke, Mayor
Public Welfare and Finance,
Recreation
Phone AX 7-0593

Kenneth F. Rupprecht
Roads, Streets, Sewers,
Water, Plumbing Inspector
Phone CH 7-0922

John J. Flanagan
Planning, Zoning,
Shade Trees, Building Inspector
Phone CH 6-0651

Jack Pincus
Board of Health, Sanitation,
Public Buildings, Grounds
Phone AX 7-1654

James J. Bates
Police, Police Reserves,
Street Lighting, Fire, Civil Defense
Phone AX 7-1617

TAX COLLECTOR	Caroline Christ
TAX ASSESSOR	Charles A. Kern
TOWNSHIP CLERK	Edna L. Swanson

Emergency Calls

POLICE	KILMER 5-4232
FIRE	KILMER 5-4232
EMERGENCY SQUAD	
RESCUE AMBULANCE	KILMER 5-9580

Municipal Staff–Charter 7-0922

Building Inspector	J. Howard Kern
Chief of Police	Carmen Canastra
Civilian Defense	Gerald Liloia
Plumbing Inspector	Thomas Dowgin
Purchasing Agent	Robert Frantz
Recreation	Edward Andrews
Secretary Board of Health	Charles A. Kern
Shade Tree Commission	Fred Brandt
Treasurer	Inez B. Angell
Water Department	Ann Wasserman
Sewer Department	Charles Stillwell
Zoning Officer	Robert Frantz
Attorney	Morris Roth
Magistrate	George Nicola
Court Clerk	Arlene Koch
	CHarter 7-1408
Welfare Director	Marjorie O'Connell

Board of Education
JAMES CLANCY Superintendent

Planning Board
FRED GILBERT	Chairman
JUNE HELMECZI	Secretary

Zoning Board of Adjustment
FRED BISSO	Chairman
LINDA MUCHANIC	Secretary

Township Committee Meetings
1st and 3rd Monday Linwood School

Board of Education
2nd Tuesday Linwood School

Planning Board
2nd and 4th Monday Linwood School

Board of Adjustment
3rd Tuesday Linwood School

DIRECTORY OF SERVICES. A 1965 North Brunswick Township Municipal Directory includes the offices of the mayor, council, all department administrators, police, fire and rescue, municipal staff, board of education, and the planning and zoning boards.

NORTH BRUNSWICK SEEKS NEW INDUSTRY. Looking over plans in 1966 for the new Manor/North Brunswick industrial district are, from left to right, A. J. Rolleri, the Pennsylvania Railroad manager of industrial development; Clyde Nichols, the railroad's real estate agent; and Mayor George W. Luke. A Pennsylvania freight train passes by on the left during their planning conversation.

DEMOCRATIC MAYORS AND TOWNSHIP STAFF. Pictured here are politicians and public workers from North Brunswick and New Brunswick in 1966 demonstrating that neighboring communities can partner with each other to benefit the greater good. Identified in this photograph are New Brunswick mayor Chester W. Paulus (first row, third from left), township engineer Bill Dailey (second row, left) and North Brunswick mayor George Luke (second row, fourth from left).

MAYOR NICOLA SPEAKS AT DINNER. Charles Nicola, who served as mayor of North Brunswick from 1976 to 1980, was the youngest holder of that office in North Brunswick's history. Shown here, Mayor Nicola speaks to a crowd of hundreds of supporters at the North Brunswick Democratic Organization Victory Dinner in 1977 at the Pines Manor in Edison.

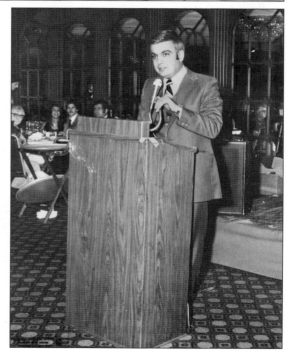

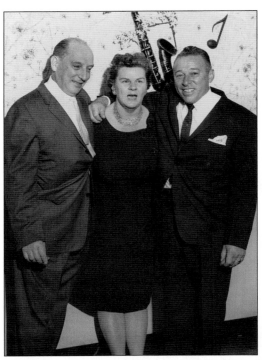

ANOTHER SOCIAL GATHERING. Featured in this photograph in the 1960s are Fred Bisso, chairman of the Zoning Board of Adjustment; Edna Swanson, township clerk; and Carmen Canastra, chief of police.

MUNICIPAL EMPLOYEES HONORED. Shown in this photograph are township employees who were honored for their outstanding service at a luncheon in the 1960s. They are, from left to right, (first row) Bernice Eckert, assistant tax collector; Fred Kern, tax assessor; and Anna Wasserman, water department collector; (second row) Caroline Christ, tax collector; Bernard Thomas, chairman of the planning board; and Edna Eckert, secretary.

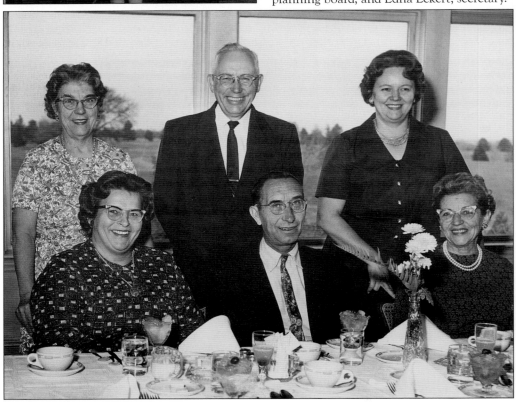

CAMPAIGN EPHEMERA. This example of campaign literature from the early 1970s shows how creative politicians could be. Using a wheel design, the front side pictured candidates not only for the township committee but also for tax assessor and tax collector. On the reverse was a tax wheel where residents could compare their local tax rate with those in other Middlesex County towns.

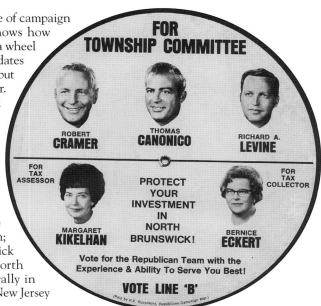

THE GOP GALS. From left to right, Joan Hobschaidt, president of the North Brunswick Woman's GOP; Mrs. John Flynn, president of the New Jersey State Republican Women; Margaret Kikelhan, North Brunswick tax assessor; and Bernice Eckert, North Brunswick tax collector, attend a rally in support of candidate Bill Cahill for New Jersey governor in 1969.

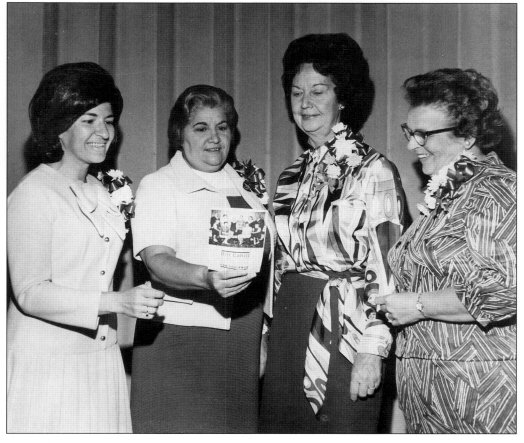

SWEARING IN OF MAYOR GILBERT. Township clerk Edna Swanson swears in newly elected mayor Fred Gilbert as his daughter holds the Bible in 1970. Mayor Gilbert served from 1970 to 1971. Since being mayor was a part-time job, Fred Gilbert continued to run Ned's Market on Georges Road.

SWEARING IN OF MAYOR PINCUS. Township clerk Edna Swanson administers the oath of office to, from left to right, councilmen Frank Pelly and Edward Leppert, deputy mayor Charles Nicola, and Mayor Jack Pincus, who served as mayor from 1972 to 1975. This picture represents an all-Democratic mayor and council.

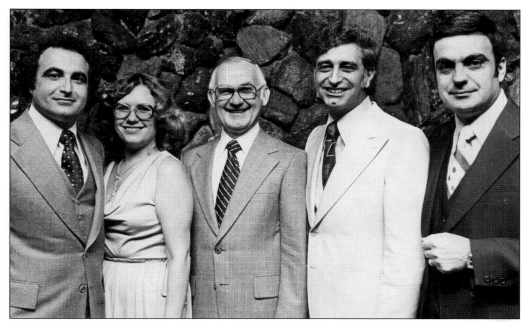

NORTH BRUNSWICK ELECTED PUBLIC SERVANTS. Political figures pictured here together in 1980 are, from left to right, councilman Frank Puleio, councilwoman Joan Dambach, councilman Joseph Fekete, deputy mayor Sylvester Paladino (later mayor from 1981 to 1982), and Mayor Charles Nicola.

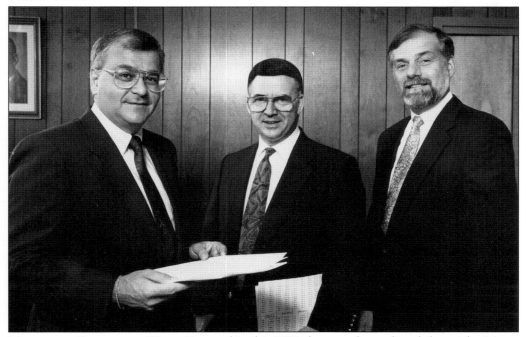

MAYOR AND COUNCIL AT WORK. Featured in this 1987 photograph are, from left to right, Mayor Paul Matacera, councilman Salvatore Liguori, and councilman Joseph Fritche. Matacera served as mayor of North Brunswick from 1983 to 1999.

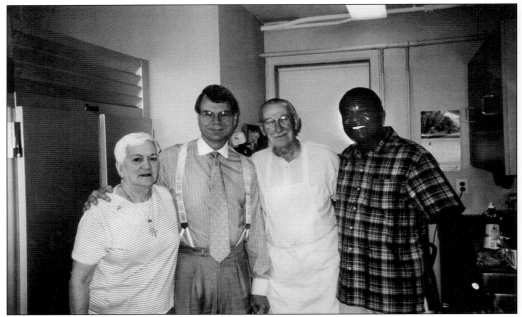

MAYOR SPAULDING VISITS SENIOR CENTER. Mayor David Spaulding visits the senior center on Linwood Place, spending time with senior volunteers before serving a special luncheon. Spaulding served as mayor from 2000 to 2003.

MAYOR FRANCIS "MAC" WOMACK. Francis M. Womack was elected mayor in January 2004 and still serves in that capacity today. Seen in this picture at a luncheon with Gov. James McGreevey in 2005, Mayor Womack started his political career here in town as a councilman in 2001. Under his administration, the Otkin Farm was developed into the 105-acre community park, Sabella Park was refurbished, and the Pulda Farm was acquired as open space.

Seven

THROUGH THE YEARS

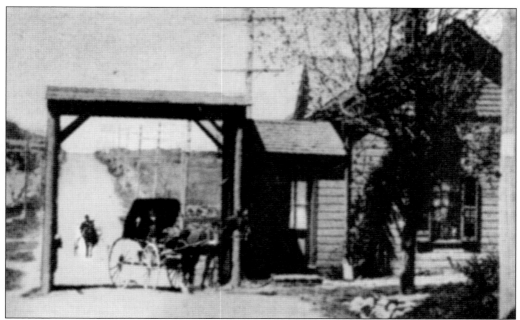

NO E-Z PASS HERE. The word *turnpike* indicates a road where tolls are charged, and the name comes from the pike, or bar, which was suspended across the road where tolls were collected. Charges on the Trenton–New Brunswick Turnpike, now known as Route 1, in 1850 were carriages, 1¢ per mile; horse and rider, one half cent; and one dozen calves, one half cent per mile. Churchgoers and farmers were not charged.

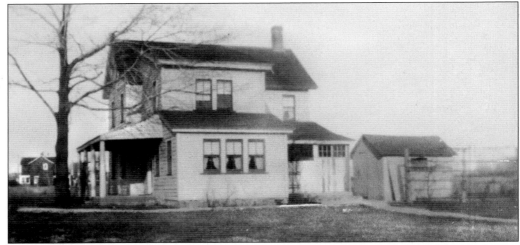

THE COTTAGE. In the early 1900s, Thomas Buckelew bought the Adams Rail Road Station house, dismantled it, and moved it to Georges Road to a lot next to his home. The station became the core for the five-room residence that would be known as "the Cottage," shown here around 1940. At first used for vacations in the country, it was later rented to two teachers, Miss Williams and Miss Wilcox, who taught at the Maple Meade School across from the Pulda Farm. At that time, Thomas Buckelew was on the school board. (Courtesy Dorothy G. Rupprecht.)

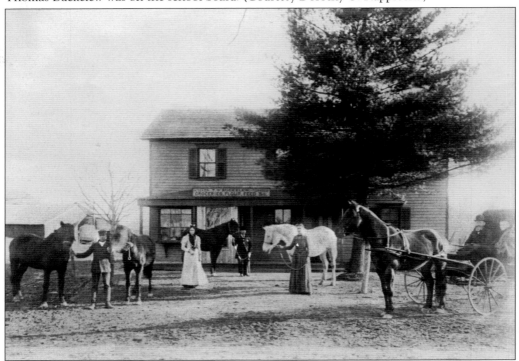

LET'S GO SHOPPING. There was plenty of parking for horses at T. W. Buckelew's Groceries, Flour, and Feed store, located at 404 Old Georges Road. Pictured here in 1890, the first gentleman on the left is Louis E. Phillips, age 28, the grandfather of current North Brunswick resident Carl E. Hirrschoff. (Courtesy Carl E. Hirrschoff.)

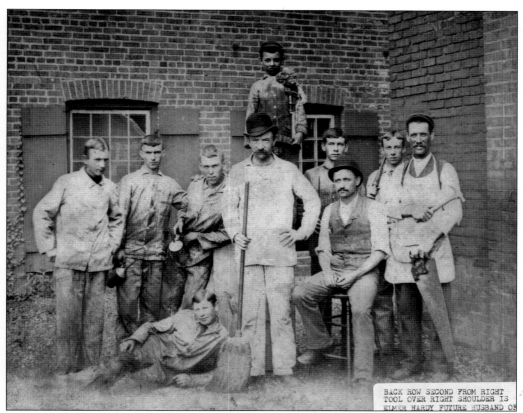

BACK ROW SECOND FROM RIGHT
TOOL OVER RIGHT SHOULDER IS
ELMER HARDY FUTURE HUSBAND OF

WORKMEN PAUSE TO POSE. The basic tools like saws, brooms, and wrenches have not changed much since the 19th century, but today's child labor laws would prevent the boy from working with such implements. Elmer Hardy, pictured here in 1890, second from right in the back row with a tool over his right shoulder, is the future husband of Eleanor R. Van Deursen and the future father of Mildred Hardy.

SLOW DOWN IN OUR TOWN. Travelers who violated local speed laws on the old Trenton–New Brunswick Turnpike met swift justice in this roadside court located just off the turnpike on Aaron Road. Court was in session between 1910 and 1950, but by the 1970s the building was abandoned.

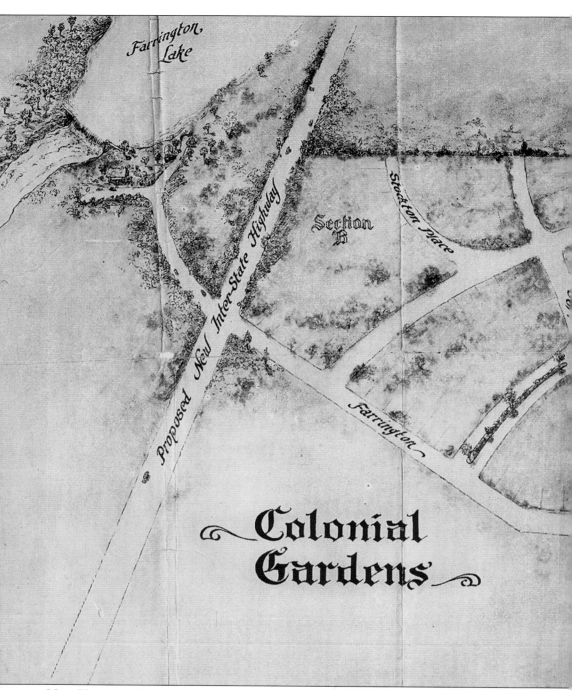

NEW HOUSING. Starting in the 1920s, goat farms, truck farms, vast areas of woods, and the open fields began to disappear. Colonial Gardens was a housing development built along both sides of Route 130, also known as Georges Road. Streets were named by the developers and they honored Revolutionary War heroes such as Paul Revere, Ben Franklin, and Richard Stockton. The main entrance into the development credited the memory of the war itself and was proclaimed

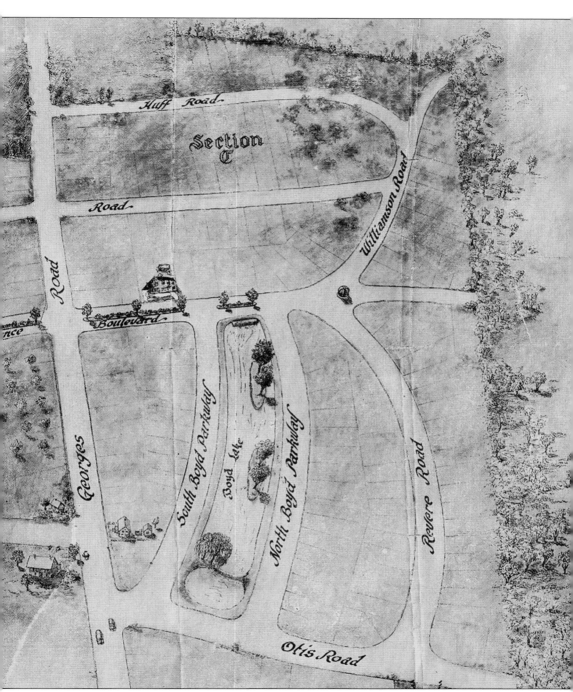

Independence Boulevard. Farrington Boulevard got its name from Farrington Lake, which in turn was named for Edward Farrington, mayor of New Brunswick from 1915 to 1918. Farrington Lake is a man-made lake developed from Lawrence Brook, one of the water supplies for the city of New Brunswick.

PROGRESS BRINGS TRAFFIC. This picture of the home of Alfred Yorston, at the intersection of Routes 1 and 130, was taken during a family gathering in 1934. Yorston was an eminent mortician and the superintendent of the Van Liew and Elmwood cemeteries. The house was razed to make room for the Route 1/130 traffic circle in the 1930s. At one point, the township committee suggested the circle be named in his honor, but no official action was ever taken. The photograph below shows the heavily trafficked circle in 1965 from the vantage point of the old Yorsten homestead's lawn. Gone now are the Middlesex County offices, the rehabilitation hospital, and the Citgo gas station, and gone too is the circle itself, replaced with a modern series of overpasses and traffic lights.

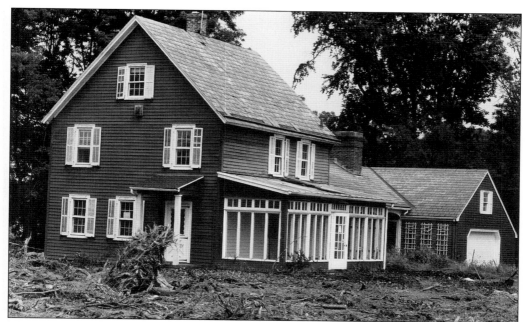

MAKE WAY FOR NEW ROADS. The Pardun family home was located just south of the intersection of Routes 1 and 130. Derelict by 2002, it was razed that year to make way for the construction of the new Route 130 overpass. Members of the Pardun family have lived in North Brunswick since the late 1700s.

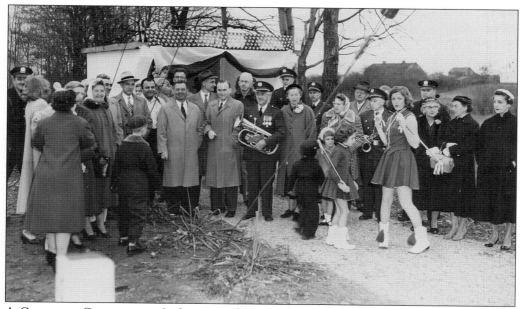

A CAUSE FOR CELEBRATION. Ladies sported hats and corsages, and a band came out to play at the dedication of a bus stop shelter on the corner of Route 130 North and Wood Avenue. The shelter was built by residents of Maple Meade Estates on land donated by Fred Bisso in the mid-1950s. This stop provided protection from the elements for commuters using the express buses bound for New York City.

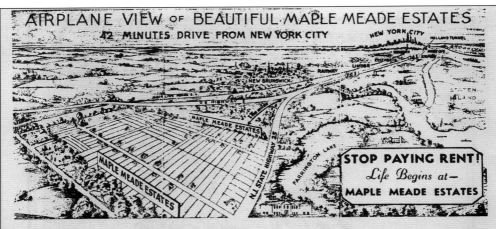
MOVE TO THE COUNTRY. Developers came to the Maple Meade section of town extolling the virtues of country living to city dwellers in the 1930s. A person could build a home with a small farm in North Brunswick and live independently of a job and a landlord, or the man of the house could commute back to the city with ease with the help of the nearby train station on Adams Lane or drive back on New Jersey State Highway 25, now known as Route 130; or he could take an express bus, which left for New York every hour during the day; or someone could have the best of both worlds by having a summer bungalow built, with house prices starting at $100 and land starting at $195.

BRUNSWICK SHOPPING CENTER. Built in 1955 and shown here in the mid-1960s, the Brunswick Shopping Center was a regional center serving the Greater Brunswick area. A 1960 inspection by Fire Company No. 1 eerily noted the lack of firewalls and that one could see straight across the ceilings of the stores. A fire in 1968 destroyed the A&P supermarket and then, the following year, an even larger fire started at Grant's lunch counter and destroyed Mile's Shoes, Pergament Paints, Tracy's, and the Fabric House, along with W. T. Grant.

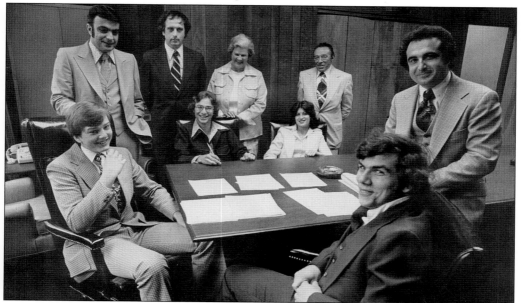

STUDENT GOVERNMENT DAY. Once a year, ninth graders from Linwood Junior High School take over the running of the township. The class of 1976 poses here with township officials. Pictured are, from left to right, student Tom Parr, Mayor Charles Nicola, deputy mayor Dominic Teneralli, student Clifford Wilson, township clerk Edna Swanson, student Kathy Costello, police chief Carmen Canastra, committeeman Frank Puleio, and student Jeff Robison.

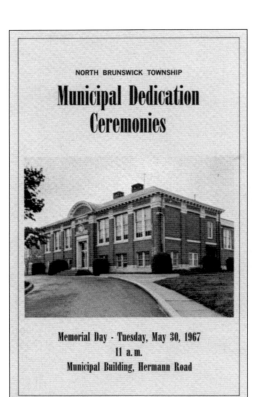

NORTH BRUNSWICK TOWNSHIP

Municipal Dedication Ceremonies

Memorial Day - Tuesday, May 30, 1967
11 a.m.
Municipal Building, Hermann Road

OLD SCHOOL—NEW TOWN HALL. As the population of the town continued to grow rapidly so did the need for additional space for municipal services. The former Parsons Elementary School was converted into modern municipal offices, a police department, and a brand new public library. Although dedicated on May 30, 1967, the building actually opened for business on January 2, 1967. This structure served as the town hall until 2002, when it was found to be inadequate and not compliant to rules established by the Americans with Disabilities Act, and a new municipal complex was built directly across the street on the former site of the Hermann Trucking Company.

OUR NEW MUNICIPAL BUILDING
Complete renovations and tasteful furnishings have transformed the former Parsons School into modern and spacious municipal offices. Upper Level shown in photos provides for Water & Sewer Dept., Treasurer, Tax Collector, Tax Assessor, Township Clerk and Machine Room. Basement Level, now being renovated, will provide for Planning Board, Board of Adjustment, Engineer, Purchasing Agent and Building & Plumbing Inspectors. Rear of building will house Police Dept., Police Court, Judge's Chambers and Court Clerk.

OUR NEW PUBLIC LIBRARY
Ample space has been provided in Municipal Building for establishing the North Brunswick Free Public Library. The library is now in complete operation, with membership open to all North Brunswick residents.

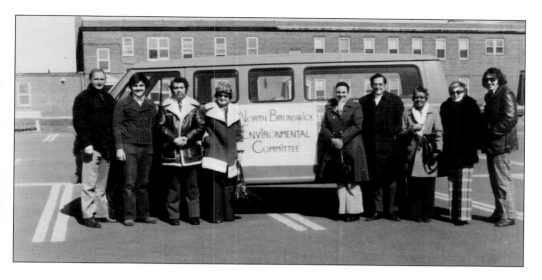

EARLY EFFORTS FOR GOING GREEN. Caring for the environment in North Brunswick was started far before it was fashionable. As seen in these photographs, the township had an North Brunswick Environmental Committee as early as the 1970s. Carpooling was encouraged as shown by the van in this photograph, and residents were also encouraged to recycle as seen by the advertisement on the building located at the corner of Milltown and Georges Roads. Recycling became mandatory for all residents in the early 21st century. Interestingly enough, the store used as a dry cleaner in the photograph is still used as a dry cleaner although with a new owner. Alan's Cake Box Bakery is currently Little Caesar's Pizza, and the building with the North Brunswick Environmental Committee's advertisement on it is now Polanco's Training Center and Professional Services.

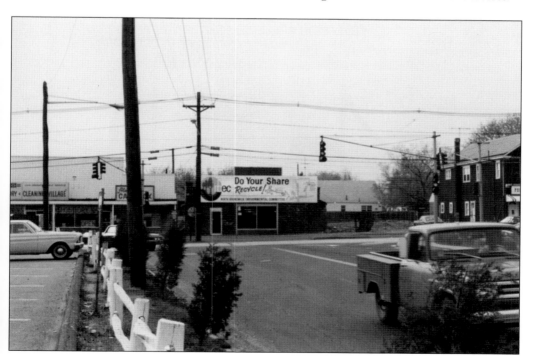

BREAK A LEG. The children's drama group, established by the recreation department in the early 1960s, proved to be so popular that adults wanted to get into the act. Directed by Bruce Chandlee, the first production of *Guys and Dolls* was performed at the Parsons Elementary School in 1971. Gerry Fink (left) and Shelly Gluck perform "Fugue for Tin Horns." (Courtesy of Jeff McBride.)

THAT'S ENTERTAINMENT. In 1972, *South Pacific* was performed at Parsons Elementary School. Seen here, the men of the cast perform "There Is Nothing Like a Dame." Pictured from left to right are Wayne Kotroba, Jeff McBride, unidentified, Gerry Fink, Jim Linegar, Joe Fritche, unidentified, Sam Vigod, Shelly Gluck, and unidentified. (Courtesy of Jeff McBride.)

THAT'S SHOW BIZ. In 1979, Steven Sondheim's musical *A Funny Thing Happened on the Way to the Forum* was presented by the Adult Drama Group at North Brunswick Township High School. Featured from left to right are Jerry Powers, Richard Goodman, Jeff McBride, Rod Rodrigues, Jim Linegar, and Don Gordon (kneeling). (Courtesy of Jeff McBride.)

HOW ARE THINGS IN GLOCCA MORRA? In 1973, the Adult Drama Group presented Harburg and Saidy's *Finian's Rainbow*. Shown here performing the song "When the Idle Poor Become the Idle Rich" are, from left to right, Joe Fritche, Shelly Gluck, Lynn Weinstein, Curt Kristjanson, Jim Linegar, Phyllis Kristjanson, Brenda Morgan, two unidentified, Barbara Fritche, Dana Stein, and unidentified. (Courtesy of Jeff McBride.)

HAVING FUN IN THE SUMMERTIME. As seen in these photographs from the 1940s, beautiful Farrington Lake offered many recreational opportunities for the kids of the township. Besides the ever popular sport of fishing, boating and swimming were also allowed then. In the photograph above, the children are sitting on the old train tracks that once carried trolleys for the Brunswick Traction Company. Today Farrington Lake is surrounded by beautiful homes and restaurants and is still used for many outdoor sporting purposes.

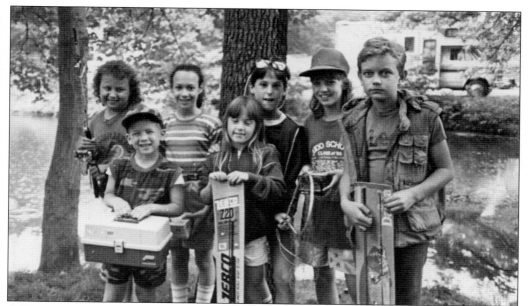

A Whale of a Tale. The annual Father's Day Fishing Derby was started by longtime township employee Bob Hermes in 1976. The first fishing derbies took place on Farrington Lake; then in the early 1980s the derby was relocated to the scenic Boyd Ponds location in Colonial Gardens. The Father's Day Fishing Derby continues to attract hundreds of participants and has turned into a wonderful community tradition.

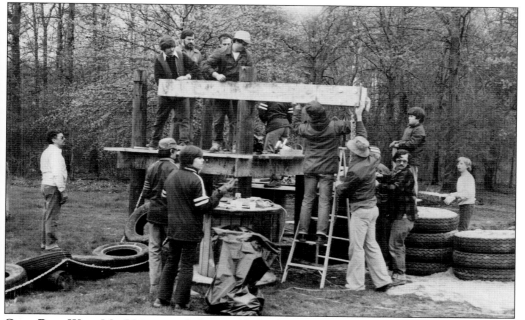

Come Play With Me. Using recycled materials for the construction of playground equipment was all the rage in the 1970s. The John Adams PTA along with the township recreation department built an ecology playground on school grounds. Pictured here helping out are Mark Fritche, Bob Hermes, Joe Fritche, and Tom Seilheimer.

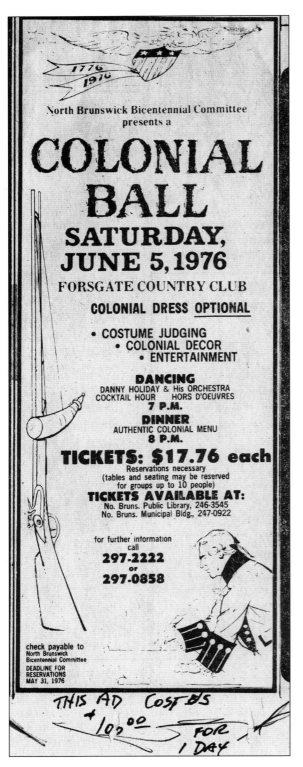

North Brunswick Bicentennial Committee presents a

COLONIAL BALL

SATURDAY, JUNE 5, 1976

FORSGATE COUNTRY CLUB

COLONIAL DRESS OPTIONAL

- COSTUME JUDGING
 - COLONIAL DECOR
 - ENTERTAINMENT

DANCING
DANNY HOLIDAY & His ORCHESTRA
COCKTAIL HOUR HORS D'OEUVRES
7 P.M.

DINNER
AUTHENTIC COLONIAL MENU
8 P.M.

TICKETS: $17.76 each

Reservations necessary
(tables and seating may be reserved
for groups up to 10 people)

TICKETS AVAILABLE AT:
No. Bruns. Public Library, 246-3545
No. Bruns. Municipal Bldg., 247-0922

for further information
call
297-2222
or
297-0858

check payable to
North Brunswick
Bicentennial Committee
DEADLINE FOR
RESERVATIONS
MAY 31, 1976

THIS AD COSTS
+ $10.00 FOR 1 DAY

POWDERED WIGS OPTIONAL. In 1976, the United States celebrated the bicentennial with fireworks, parades, flotillas, and parties. North Brunswick joined in the festivities by holding a Colonial Ball at the Forsgate Country Club in nearby Monroe. Attendees were treated to an authentic colonial menu for dinner and dancing with Danny Holiday and his orchestra. Tickets were available at the clever price of $17.76 each.

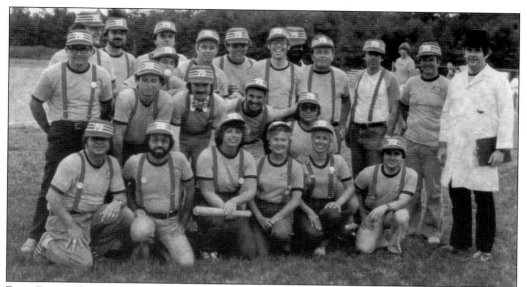

PLAY BALL. This "colonial baseball team" is really a group of township residents who participated in one of the Bicentennial Committee's observances of this nation's 200th birthday by playing a game of rounders, a forerunner of baseball. This game was sponsored by the North Brunswick Township Recreation Department and took place on July 4, 1976.

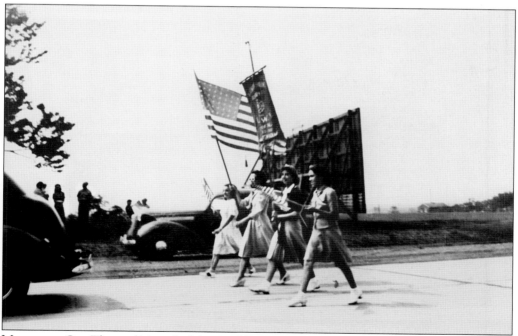

MARCHING ON. The tradition of a Memorial Day parade started in the late 1940s. The original parade route was along Old Georges Road going past the Maple Meade School, when the area was obviously still farmland. These young ladies marching in the parade represented Livingston Park School.

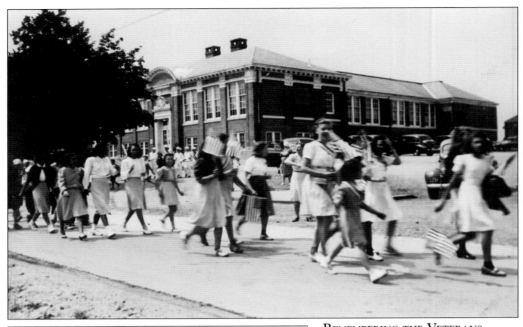

REMEMBERING THE VETERANS. Students wave flags as they march down Old Georges Road in front of Maple Meade School in this 1940s photograph of the annual Memorial Day parade.

BOY SCOUTS PAY TRIBUTE TO VETERANS. The Boy Scouts march in formation in a 1940s Memorial Day parade. The annual parade remained a tradition in North Brunswick until 2008.

TIMELESS PARADE TRADITIONS. A time-honored tradition in the Memorial Day parade was the decorated bicycle parade. The bike parade followed the marching units and floats and consisted of township children who took much pride in decorating their bicycles in red, white, and blue and peddling their way down the parade route. Pictured above in a photograph from the late 1940s is an unidentified Boy Scout showing off his decorated bicycle. Pictured below is Fred Kikelhan, lifelong resident of North Brunswick, getting ready to join in the parade route in the late 1950s. (Below, courtesy of Greg Kikelhan.)

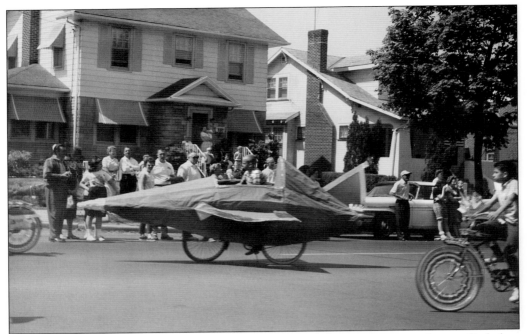

ROCKET MAN. By 1964, the United States had entered the space race, and every little boy dreamed of being an astronaut and flying to the moon. This unidentified cyclist had to settle for a decorated bicycle and flying up Livingston Avenue. In 1963, the housing development known as North Brunswick Village was built, and the developer honored early astronauts by naming streets for them—Grissom, Shepard, Carpenter, and Glenn.

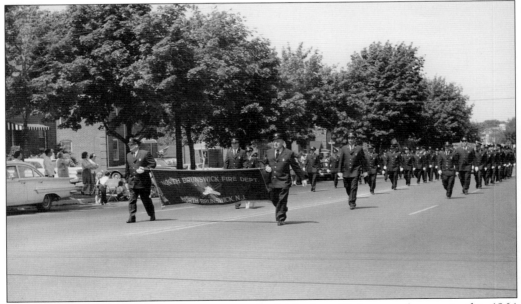

FIREMEN ON PARADE. The fire department steps high along Livingston Avenue in this 1964 Memorial Day parade picture. It is safe to assume that the Ladies Auxiliary must be following close behind.

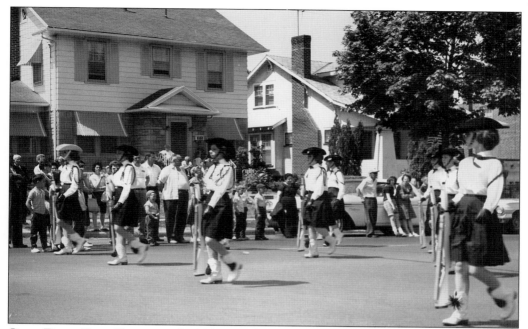

GIRLS DRILL TEAM PERFORMS. In 1964, North Brunswick teenagers attended New Brunswick High School, as the town did not have its own high school until 1975. The drill team pictured here is from New Brunswick High School and had North Brunswick residents as team members. The very real looking rifles are in reality wooden props.

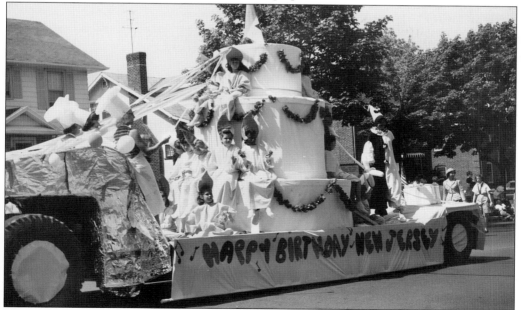

HAPPY BIRTHDAY NEW JERSEY! New Jersey celebrated its tercentennial in 1964, and North Brunswick proudly celebrated with a birthday cake float in the Memorial Day parade. As seen in this photograph, the North Brunswick children riding along on this float are happily dressed as lit candles.

www.arcadiapublishing.com

Discover books about the town where you grew up, the cities where your friends and families live, the town where your parents met, or even that retirement spot you've been dreaming about. Our Web site provides history lovers with exclusive deals, advanced notification about new titles, e-mail alerts of author events, and much more.

Find Your Place in History.